TEUN HOCKS

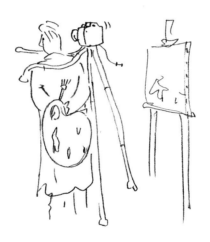

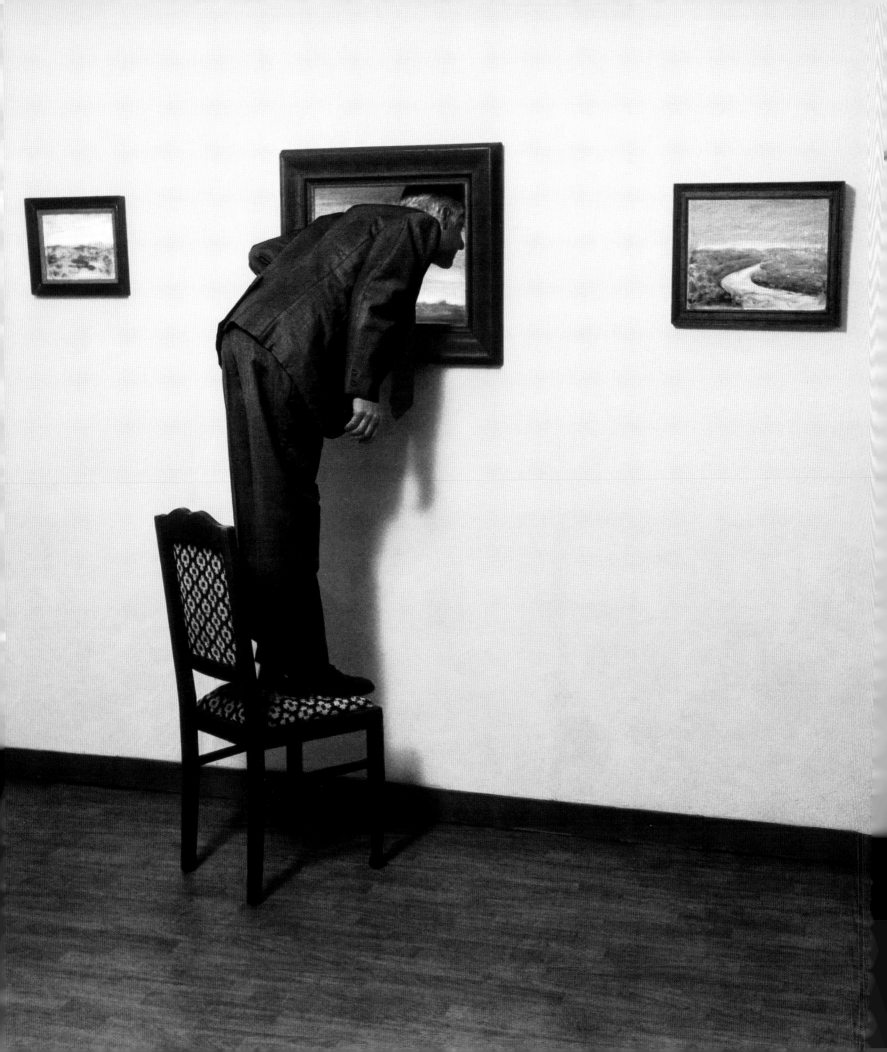

TEUN HOCKS

ESSAY BY JANET KOPLOS

aperture

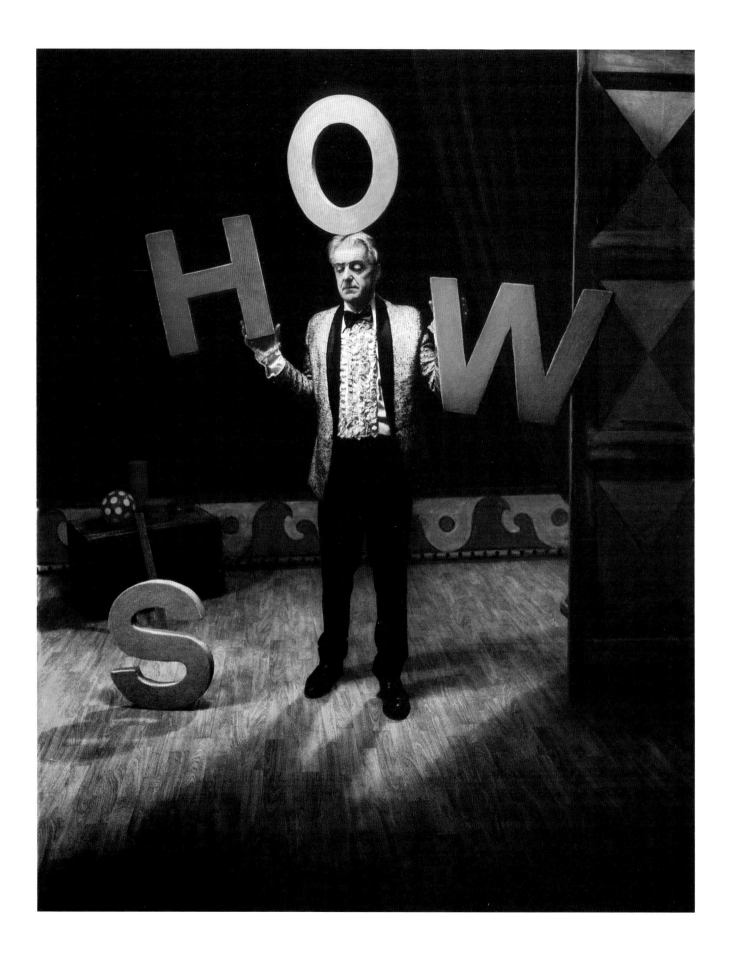

TEUN HOCKS: PERFORMANCES FOR A SINGLE EYE

A CARTOON BY TEUN HOCKS SHOWS A PAINTER, who has turned away from his easel, being embraced—consoled, perhaps—by an anthropomorphic camera on tripod legs. This sketch might be meant as a historical joke, looking back to the invention of the camera, which once seemed to rob painting of its reason for being. But more likely the drawing is Hocks's expression of his own experience and of his distinctive blend of painting and photography.

An artist who crosses genres, Hocks studied at the Academie Sint Joost, in the town of Breda in his native Holland. His father was an amateur photographer, "an old-fashioned one. He made his own enlarger. When I was a small kid I watched my father in the kitchen when he was enlarging," Hocks says.[1] His family, he adds, liked "to be busy with photography or to build something with wood or to make something from paper." This background seems prophetic now, but at first it led him astray. Since he already knew photography, he didn't want to study it. "I wanted to be an artist. I wanted to paint."

After art school, Hocks made Super 8 films (beginning in 1977) and created performances (beginning in 1979). "The performances I did were kind of reactions to the serious performances that were going on in the 1970s. I made very short things, a little bit like my photo works, with a point at the end, something funny sometimes." (He also made small photo pieces and drawings.) He thought of himself as an entertainer; he would put the props in his car and travel from place to place in Holland doing his acts, until he gave that up in 1985. The performances have influenced his later works: "It's the theatrical part of it that I still like," he says.

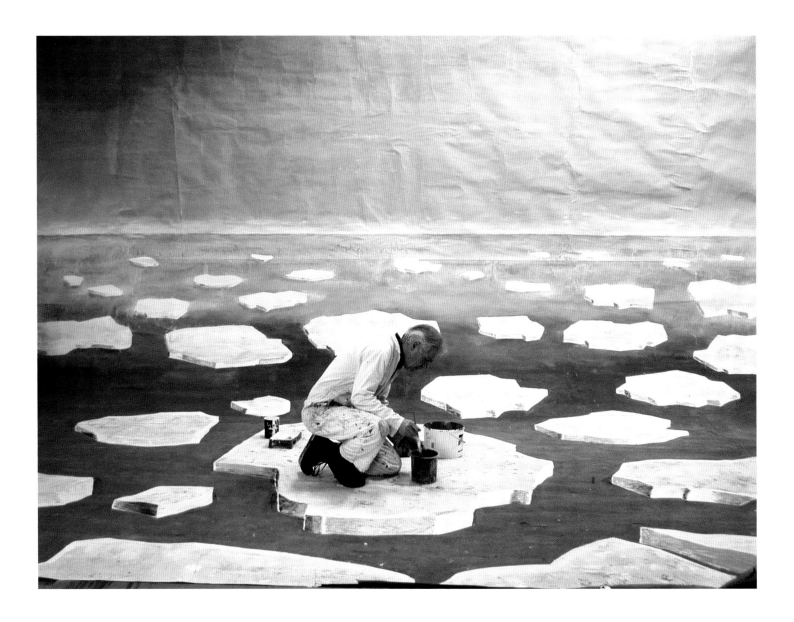

Teun Hocks painting the set for *Untitled*, 2003

MANY ASPECTS OF THEATER REMAIN IN HOCKS'S WORK. But he now performs a one-man show for the single eye of the camera (surrogate for his own) rather than for a live audience. Hocks himself is the playwright without words. He develops an idea through a cartoon, or several. Then he paints a backdrop, finds or makes props, obtains whatever he needs in the way of costume, and does the lighting. He tests the effect with a Polaroid. Even after he takes his final pose against his backdrop and clicks the shutter of his Horseman 6-by-9 cm technical camera, he is still not finished. Next he paints over the black-and-white print, enlarged to three feet tall or more, setting it on a painter's easel to work. This, too, might be a historical joke, a recollection of hand coloring in the days before color film. His painting, however, is unlike that tender tinting. It is a means of maintaining a peculiarly doubled reality.

Hocks's starring role in his own photographs may recall the more widely known work of Cindy Sherman, but there are many differences. Sherman is celebrated for her

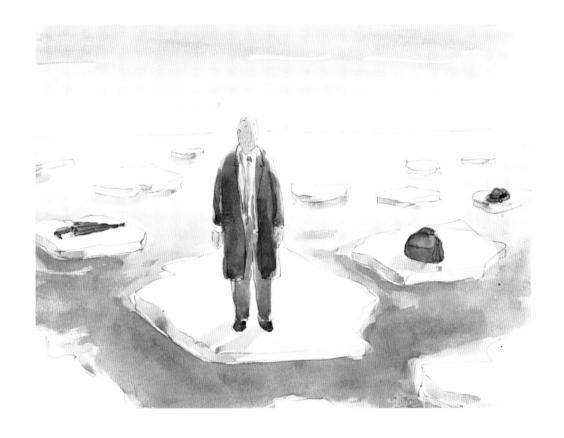

Drawing for *Untitled* (2003), 2003
Pencil and watercolor on paper,
8¼ x 11⅝ in. (21 x 29.7 cm)

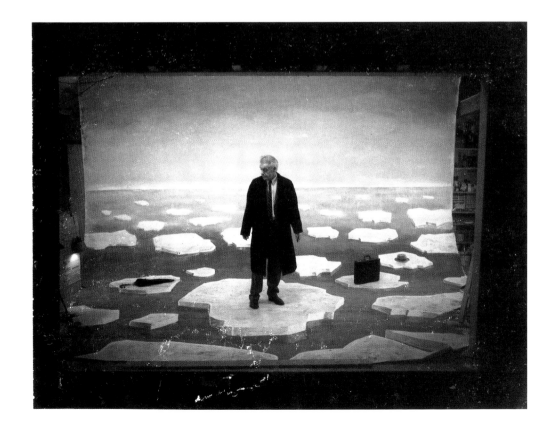

Polaroid study for *Untitled*, 2003

adaptation of visual conventions from film and for her more recent forays into the repellent and macabre. Hocks, by contrast, is often avuncular as he devises simple lessons based on his observation of human behavior. Like Sherman's Film Stills series, many of his works imply a sequence of events—but not noir drama. He takes the role of Everyman, whom he sees as amusingly flawed. His work is actually more akin to that of other artists in Holland, who, beginning in the 1970s, used photography as a tool to explore perceptual, physical, and psychological effects—notably Ger van Elk, Wim T. Schippers, Pieter Holstein, Sigurdur Gudmundsson, Bas Jan Ader, and Pieter Laurens Mol.

Hocks shares with many of his compatriots a notable predilection for wry humor. The human comedy, especially with the artist himself as the butt of the joke, makes a frequent appearance in Dutch arts—and not just in painting or photography. Some admired musicians—for example, the jazz musicians of the Willem Breuker Kollektief—have made a practice of interleaving their music with slapstick. Younger artists carry a heritage of deadpan humor into new forms, such as Paul de Reus's mixed-media figurative sculptures and Marijke van Warmerdam's comically low-key videos.

Hocks is the master of the short story compressed into a single image. A classic Hocks work is one I refer to, for convenience, as "The Failed Suitor." (He rarely titles his

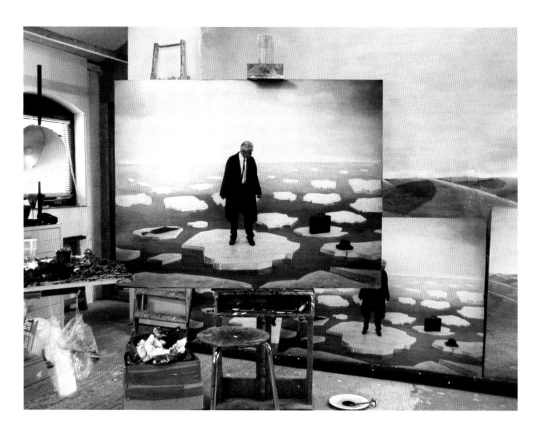

Untitled, 2003, on the easel
in Teun Hocks's studio

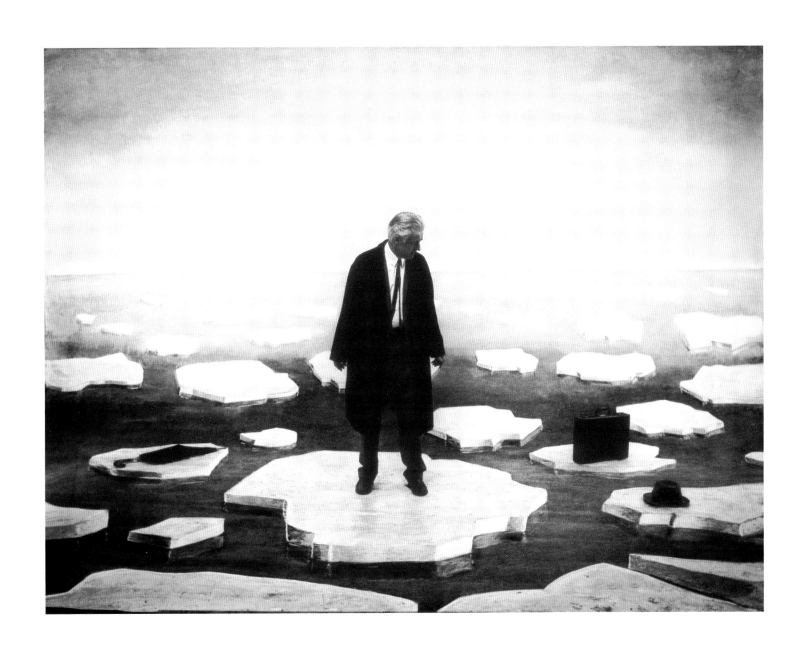

Untitled, 2003
Oil on toned gelatin silver print,
48⅞ x 63¼ in. (125.5 x 162 cm)
Edition of 3, plus 1 AP

Drawing for *Untitled* (1990), 1989
Pencil on paper,
10⅞ x 14¾ in. (28 x 38 cm)

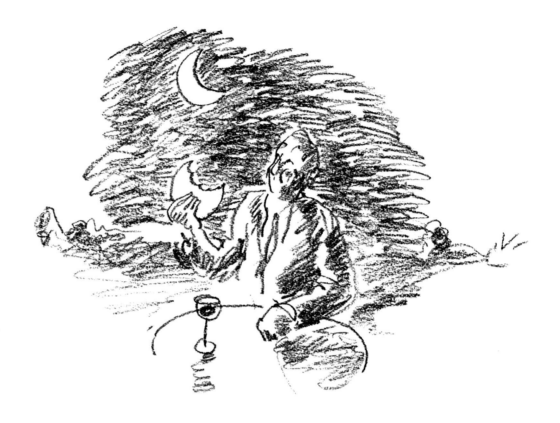

OPPOSITE

Untitled, 1990
Oil on toned gelatin silver print,
67½ x 50⅝ in. (173 x 130 cm)
Edition of 3

works.) Everyman sits alone on a park bench, beneath a crescent moon, dressed in an overcoat, suit, and tie. A paper-wrapped bouquet of tulips lies at his feet. Beside him on the bench is an opened tube of sugar cookies, gift ribbon loosened. He has just bitten into one, leaving a perfect crescent, mirroring the moon above him. The scene is romantic, slightly poignant, but still amusing. So things didn't go well. But at least he got to keep the cookies!

His cartoon for the work is revealing. In this initial conception, Everyman sits at a bistro table looking at the bitten cookie. Even a casual viewer can guess that the artist's recognition of a formal parallel between the curve of a bite and that of the moon must have sparked this work. That is the focus of the drawing. But why would someone eat cookies at a café? At this point, Hocks had established only the visual resemblance but not the rationale. The park-bench setting provides a story, a human dimension. The tone of this work reminds me of an extraordinary version of Chekhov's *Uncle Vanya* that I saw at the Guthrie Theater in Minneapolis some years ago. A typical performance of this play emphasizes frustration and pathos, but this version was a gentle slapstick, as if all the characters were mentally rapping their foreheads and saying, "Oh, foo! Why don't things ever go right!" So it is with much of Hocks's work. Humor becomes a strategy for endurance.

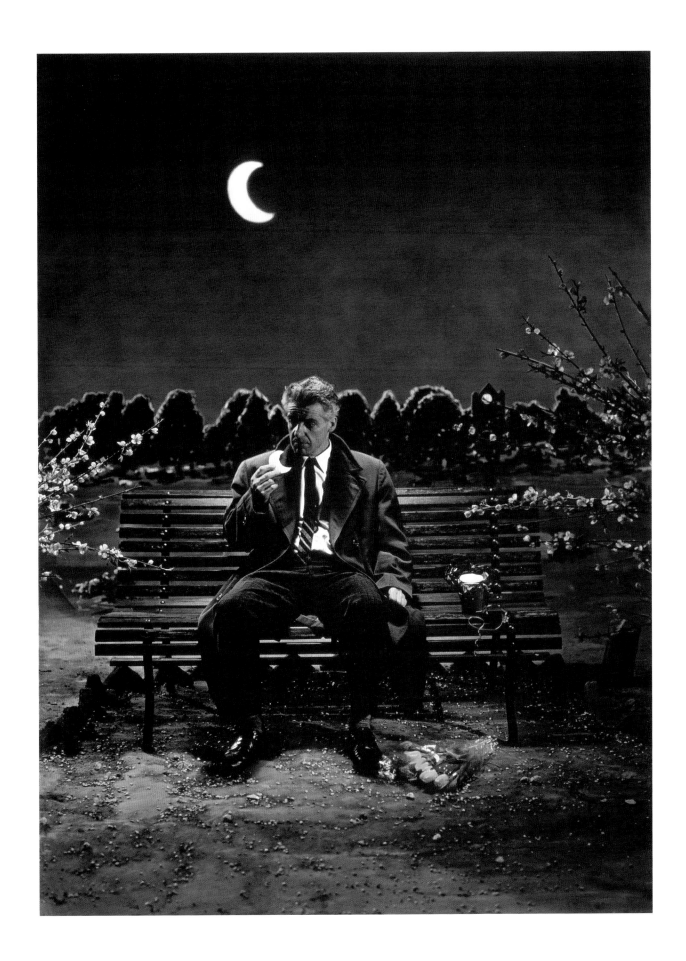

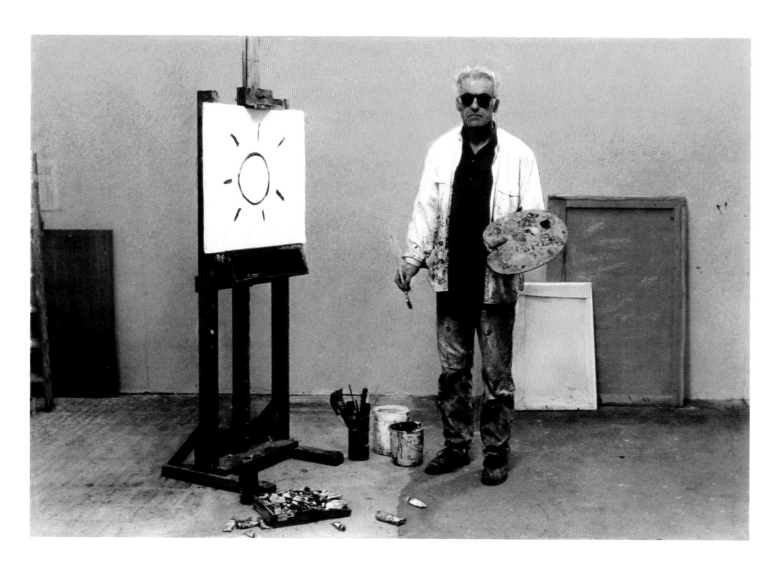

Untitled, 2003

Oil on toned gelatin silver print,
11 7/8 x 15 3/4 in. (30.5 x 40.5 cm)
Edition of 3

OTHER WORKS BY HOCKS ARE SPOOFS OF ART-MAKING CONVENTIONS. In a 1990 work (page 30), Everyman kneels at a toy train track, setting his little steam engine off on a circular route that will bring it back, through the laws of perspective, to run over him in life-size. In another work we see a painter wearing sunglasses, as if dazzled by his own depiction of the sun icon (circle and rays). This work might allude to the power of artistic suggestion. Or perhaps the dark glasses indicate the artist's blindness to the cliché he has produced.

These works are not elusive or indirect. Nearly always, the important elements of Hocks's images can be conveyed in a sentence or two. They establish the situation efficiently and trenchantly, like a good political cartoon. They need no accompanying text to be understood, not even a title to point you in a certain direction. They are pure visual communication. Yet these works are not logos or signposts, for just as the "Painter of the Sun" image can be interpreted in several ways, Hocks's best works are so masterfully calibrated that they can seem "obviously" to express quite different things. The images may reflect the viewer as much as the artist.[2] Hocks would have it so, which is why he forgoes titles that commit to a single meaning.

In addition, the works avoid being simple signs because they often have a serious undertone, or because they turn on a subtlety or detail. For instance, you might glance at a 1994 work and merely see a man looking into a lighted store window at night (page 45). Your eyes are first caught by the grotesque masks and party hats on display. Then, like a punch line, comes your realization that one hat aligns with the reflection of the man's face, so that he wears a dunce cap. The contrast of his sad-sack face to the festive window also comes secondarily, changing the tone and the implications. Outside the party and alone in the evening, he looks on, wistfully.

This kind of looking, not infrequent in Hocks's work, recalls Svetlana Alpers's assertion, in her book *The Art of Describing,* that the Dutch of the seventeenth-century Golden Age were distinguished from their Italian peers by their interest in empirical observation and description of ordinary life.[3] Hocks's work carries on this tradition. Acting as an observer or describer, he is not making works about identity or self-expression. He never narcissistically focuses on his own story. Although he says "I'm sure there must be something [of me in it] because sometimes it's so easy for me to play that role," he adds, "but it's not directly autobiographical. I always try to make something that counts for everybody, that's just like a collective dream."

THE DELIGHT IN HOCKS'S WORK is greater for anyone who knows Holland past or present, although lack of this knowledge is rarely an obstacle to appreciation. Dutch art after the Golden Age has not been as influential in America as French or Italian painting, yet many images from Holland are broadly familiar. One such feature is the rural landscape, which Hocks portrays as flat and green, always with a village on the horizon. It is polder rather than the American plains, but charming all the same, harking back to some storybook rural history.

Hocks's studio is in the countryside. When I visited in the early 1990s, he demonstrated how at home he was with neighborhood poultry by encouraging one of the birds to hop onto his lap. That local knowledge undoubtedly spurred his image of Everyman sleeping against a haystack with a rooster on his knee. (It evokes Little Boy Blue's indolence as well as scenes from Brueghel; page 72.) When the setting is big, open meadows, he is quoting the landscape of central and northern Holland. "I was there as a child," he says. "I inhaled it!" He depicted this landscape even when his studio was in Breda, which has more trees.

In Holland the implications of the stereotypical rural scene are not always benign. For one thing, the topography can be boring. One reason the Dutch have been inveterate travelers is the urge to see other options. This wish may be captured poignantly in an image showing Everyman facing a rainy window in which we simultaneously

Hats, 2004
Pencil on paper, 8¼ x 11⅝ in.
(21 x 29.7 cm)

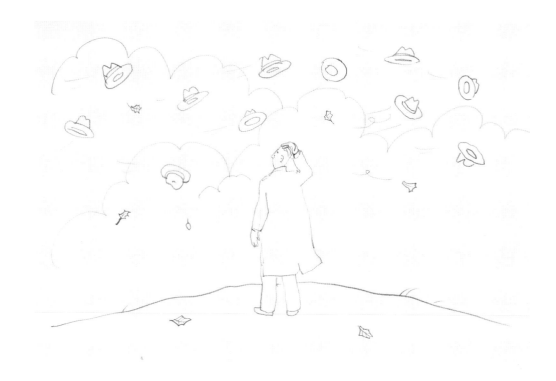

see his reflected face and a path going off into the distance, leading to who-knows-where (page 88). Hocks often opts for exotic locales such as cliffs, mountaintops, volcanoes—all features entirely absent from Holland—as if dreaming of greater excitement. He reveals this urge in his depiction of a plein air painter carefully studying a placid river as he paints a turbulent storm scene (page 80). Hocks's renderings of the flatlands of Holland and of drastically un-Dutch settings could both be said to reflect Dutch preferences.

Holland is a nation of small towns, and in small towns everyone knows everyone else's business. It's hard to be alone in Holland. Historically, a desire for privacy has been suspect there, which might be another reason people want to get away. Thus, Hocks's aloneness in nearly all his images may begin with convenience and his wish to control all aspects of his art-making process (also Cindy Sherman's justification), but it also yields a complex assortment of other readings. It can suggest a kind of misanthropic insistence on isolation, which is certainly the case in his image of a curmudgeon on a rural road (page 48), his ears stopped with corks against the pleasantness of a singing bird. (Since he wears a suit and overcoat, and carries a briefcase, another interpretation might be that a businessman forgets life's sensory pleasures.) The figure isolated on a mountaintop or ice floe has repeatedly attracted Hocks. Does it offer hope or

punishment? From a mountaintop, Everyman might have a godlike perspective, but every option leads downward (page 33). The man on an ice floe whose hat, briefcase, and umbrella are drifting away from him on separate slabs of ice might be read as a person without social connections, coming apart.

Aloneness can express longing. A frequent Dutch theme even in the Golden Age, longing may be seen in Vermeer's women by the window: the window represents not just a practical source of illumination but also the larger world outside. Hocks's scene of Everyman sticking his head through a "window" into a painting's other world is both an art joke and, perhaps, an extreme example of such desire for someplace else (page 62). A comical yet poignant variant is Hocks's image of a ship in a bottle on a beach, yearning for the sea (page 50).

Landscape in Holland—a country that is partly below sea level—can also convey a measure of vulnerability. Within living memory, a breach of the sea dikes resulted in catastrophic flooding. Hocks pictures no such dramatic disasters—at most there are windstorms (page 25) and that man on the ice floe, which do suggest a degree of insecurity in the face of nature's powers. Still, in virtually all Hocks's works, Everyman treads lightly; he never seems in command of the landscape.

Dutch particularities aside, Hocks typically represents everyday experiences that are true of life anywhere in the developed world. There are many images, for example, in which a person is caught up in the immediate business of life and is not looking at the larger picture. One such is his 1990 work in which Everyman sits at a drawing table, avidly producing images of a keyhole but never thinking to look *through* the keyhole (page 34). (That's also an amusing turnabout on small-town nosiness.) In a more recent work, he shelters a small candle flame as he stands with his back to the larger illumination of the rising sun (page 66).

In earlier works, Hocks produced some unforgettable expressions of the burdens of everyday life. In 1987 he conveyed the eternity of grocery shopping, showing Everyman lost in thought as he heads home through the stars, his string bags filled with produce, bread, and wine (page 29). It's the quotidian and the celestial together, the stars seemingly representing his mental distance from the earthly cycle of consumption. Hocks has called this work one of his favorites; not coincidentally, he told the Dutch critic Renée Steenbergen in 1992, "Sometimes I get the feeling that my whole life is taking place unconsciously, as if I were not present myself."[4]

The image of a hiker with a house strapped to his back could express the happy wanderer's motto that home is wherever he is (page 26). It could also mean that we permanently carry the heritage of home—including the mindset and biases we grew

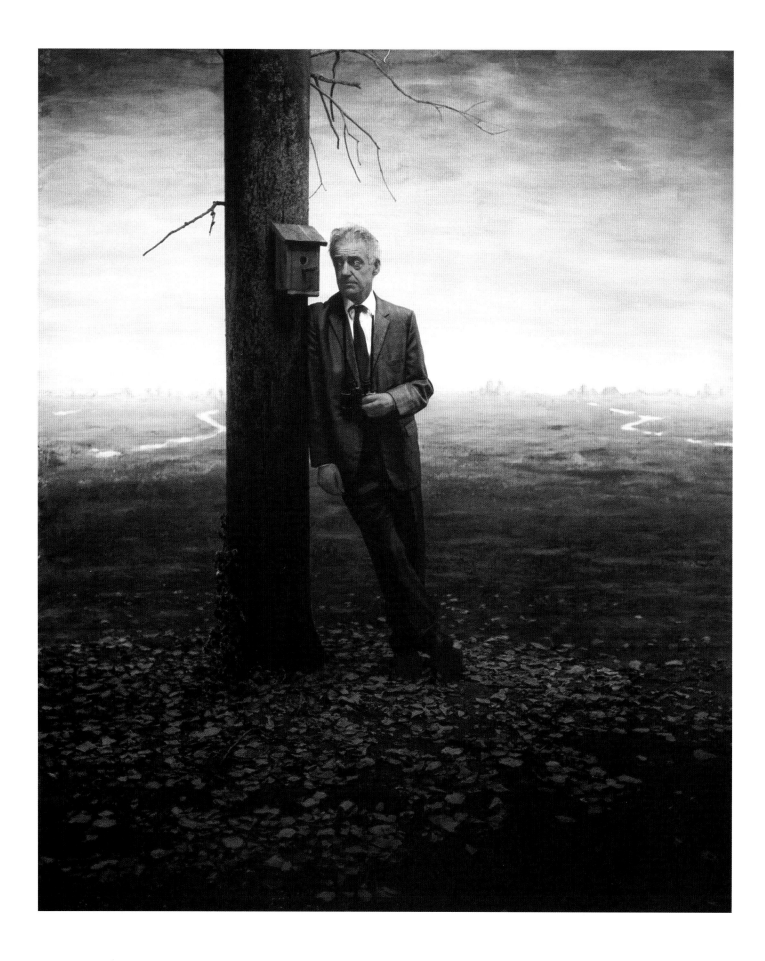

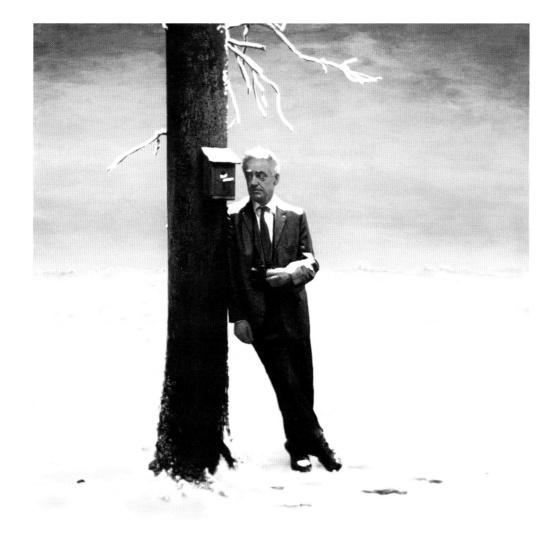

OPPOSITE
Untitled, 2001
Oil on toned gelatin silver print,
54 1/4 x 46 in. (139 x 118 cm)
Edition of 3

LEFT
Untitled, 2003
Archival digital print (Giclée print)
from digitally colored reproduction
transparency of the original work
(*Untitled*, 2001),
32 3/8 x 27 3/8 in. (83 x 70 cm)
Edition of 25

up with. Or it could embody the homeowner's lament that no matter how far away you go, you still have to shoulder the burden of mortgage and upkeep. The implication is somewhat different in the piece in which an artist sits in a rocking chair with his palette and brush in his hand, unable to reach the canvas on the rocking easel before him (page 43); in this case, the comforts of a cozy home might be a limitation. Hocks captures the circularity of the daily grind when he presents Everyman sweating from his exertions on a treadmill, which generate the power that runs a fan that cools him as he labors (page 85).

Many Hocks images have to do with naive expectation or with the recognition of futility. He presents a funny take on motivation by showing Everyman in a horse

costume, carrying a carrot on a stick to entice himself onward (page 40). Endless optimism can be read in the 2001 image of a bird-watcher leaning patiently against a tree to which a birdhouse is attached. That picture gets a new jolt in his 2003 reuse of the setting: Everyman still stands there waiting, but now dusted with snow. Not being realistic about what you want is surely the theme of the picture in which Everyman, in pajamas, stands on a rope that's being held up by the owl he hopes to catch in his net (page 39). It's something like the old joke of sawing off the branch you're sitting on. Or it might offer a complicated symbolization of trying to fall asleep.

One of Hocks's most poignant pieces is an image in which he does not appear: in this work we see a little patch of ground where a small sapling has been planted (page 55). A watering can nearby implies that someone is hopefully encouraging its growth. And presumably it's that same person who has attached a noose to the tree in expectation of its future height. The surprise that a long-term hope would be so negative makes the piece more funny than dark. This work—silly, touching, full of the illogic and inconsistencies any human is guilty of—seems to me to exemplify Hocks's remarkable equanimity, his gentle response to the human foibles he observes with such sharp-eyed clarity.

IN THESE SEVERAL WAYS, Hocks's work is true to life. Yet the most striking aspect of his pictures is their insistent artifice. His painting is carried just to the point of establishing the facts of the case, without approaching true illusion. You are always conscious of the fact that the scene is painted, not real. Asking for the willing suspension of disbelief, this is a theatrical convention of the old kind, with audience and artist in complicity. The Dutch critic Antje von Graevenitz has called this type of work "fotografia buffa."[5]

Hocks's blend of photo and painting establishes a particular balance of true and false. He does not wish the work to be photographic documentation. He does not seek the showy sleight of hand of realistic painting. He prefers that we think of ourselves in a theater, watching a man put on a show. He believes the physicality of the painted surface provides atmosphere. It creates a kind of depth, a sense of space and of warmth or coolness, as he chooses to manipulate the hues; in contrast, the basic black-and-white photograph is almost neutral. When he colors the photograph, "that's the nicest part, I think, because then you see something happen." At the same time, he makes the color transparent, so you can always see the photo underneath and know that he has not painted on something that wasn't really there. The photo is experience and fact, while "the painting gives it more distance. So it balances between both. . . . And there's a kind of handwriting in it. That touch, after a person. I'm sure if I should just paint these images it would be nothing at all."

Hocks's work might be seen as a cross between René Magritte's visual and conceptual puzzles and the seventeenth-century moralizing of the Calvinist versifier Jacob Cats, with whom Hocks shares a fascination with human behavior, but not Cats's desire to improve it. American viewers who respond to these images know nothing of this; they just appreciate the droll humor. Humor tends to be rare in American art, with the presumption being that serious issues require serious images. Hocks sidesteps sociopolitical and other fraught disputes, which are as pervasive in Holland as anywhere else, and focuses instead on individual behavior and universal experience. He offers humor as both enticement and consolation.

NOTES

1. All unattributed quotes are from the author's unpublished interview with the artist, June 28, 1993, Breukelen, the Netherlands.

2. Donald Kuspit, in an essay titled "Teun Hocks: Commedia dell'Arte Dutch Style," in *Teun Hocks: Het late uur/The Late Hour* (Breda, the Netherlands: Uitgeverij De Geus, 1999), variously describes the works as "comedy as the ultimate ingenious commentary on the insidious bleakness which makes life subtly tragic," "a consciously irrational human gesture thrown into a dehumanizing world," and "soliloquies of solipsistic solitude in a social vacuum." More persuasive to me are Kuspit's comparisons of Hocks's works to Pieter Brueghel's and René Magritte's.

3. Svetlana Alpers, *The Art of Describing: Dutch Art in the Seventeenth Century* (Chicago: University of Chicago Press, 1983), passim.

4. Renée Steenbergen, "Infinity Seen from a Stepladder," in *Alles onder controle* (Nijmegen, the Netherlands: Museum Het Valkhof, 2001), n.p.

5. Antje von Graevenitz, "Profession: Protagonist," in *Teun Hocks* (Amsterdam: Art Books Unlimited, 1991), p. 8. She adds, "The stage-managed, theatrical, melodramatic and thoroughly artificial character of his work is always maintained."

Show, 2000
Marker, correction fluid, and
colored pencil on paper,
11⅝ x 8¼ in. (29.7 x 21 cm)

Treasure Diver, 1983
Oil on toned gelatin silver print,
59⅝ x 43⅜ in. (153 x 111 cm)
Edition of 3

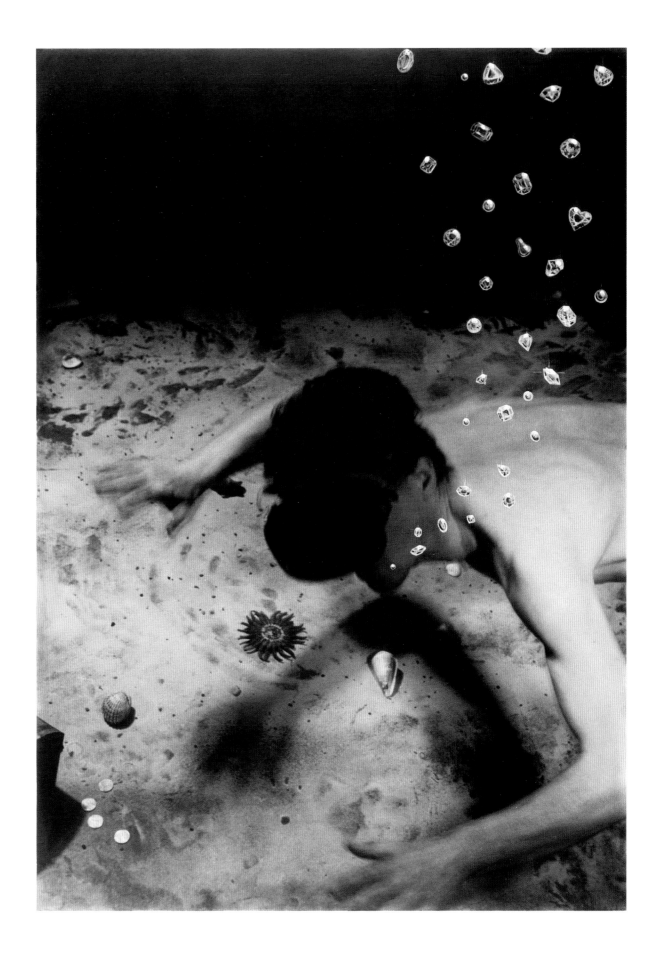

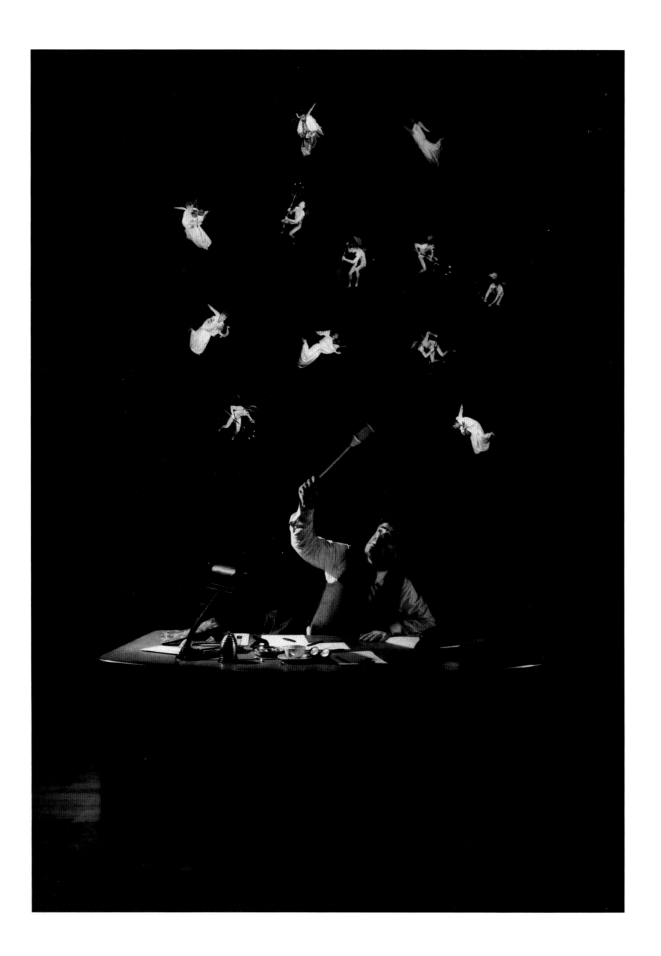

The Late Hour, 1985
Oil on toned gelatin silver print,
51½ x 37¾ in. (132 x 97 cm)
Edition of 2

To and Fro, 1986

Oil on toned gelatin silver print,

53 x 67¼ in. (136 x 172 cm)

Edition of 2, plus 1 AP

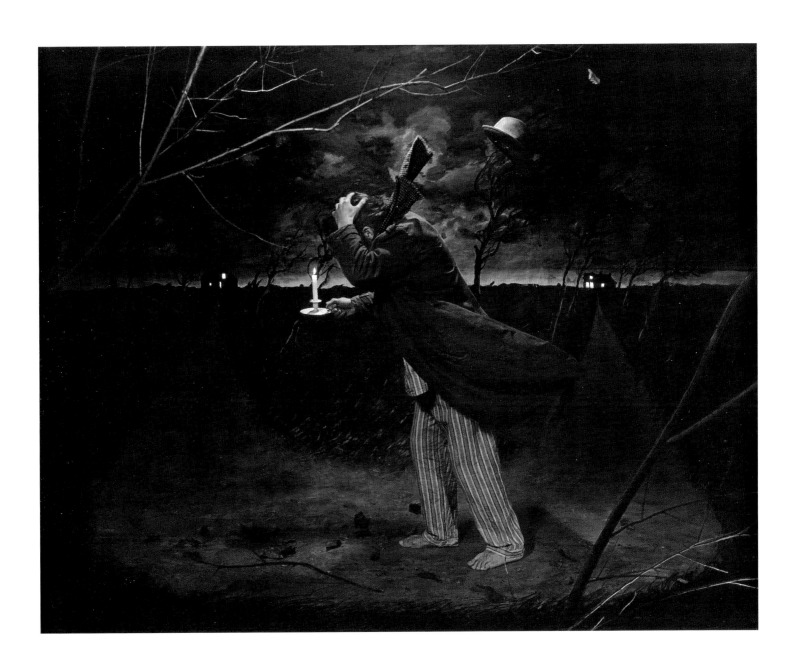

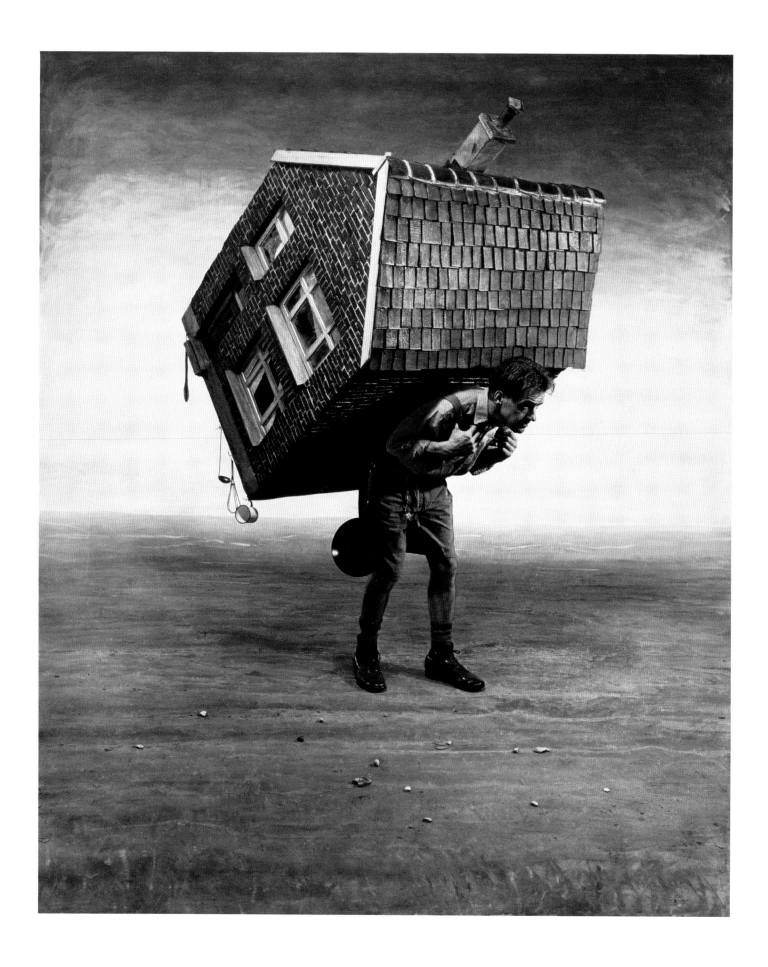

Untitled, 1988
Oil on toned gelatin silver print,
60⅛ x 50⅜ in. (154 x 129 cm)
Edition of 2

Untitled, 1987
Oil on toned gelatin silver print,
50⅝ x 37¾ in. (130 x 97 cm)
Edition of 2

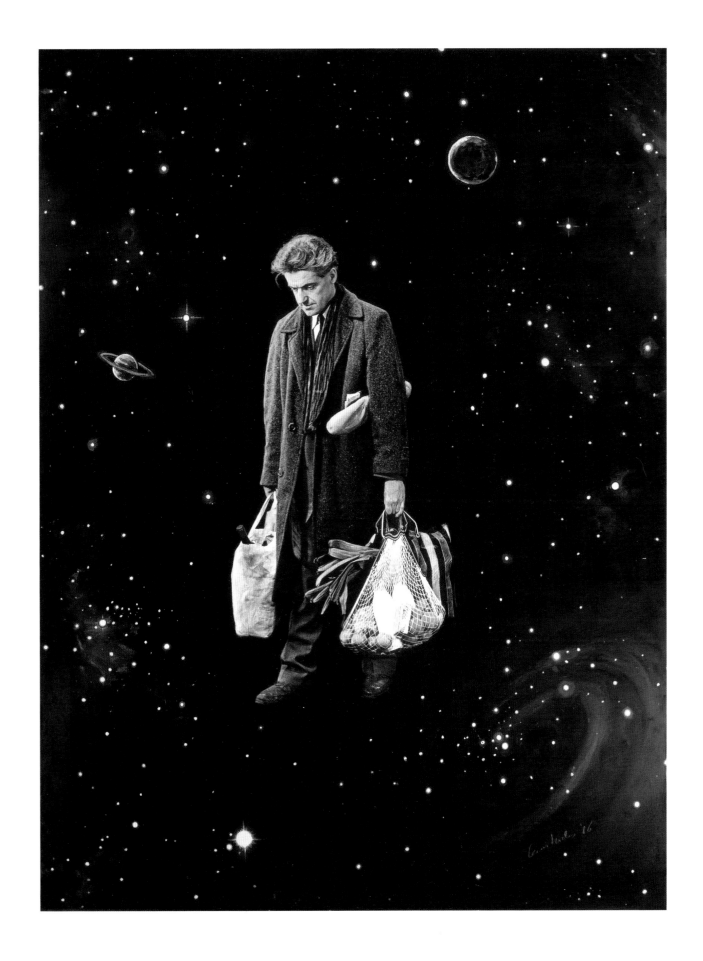

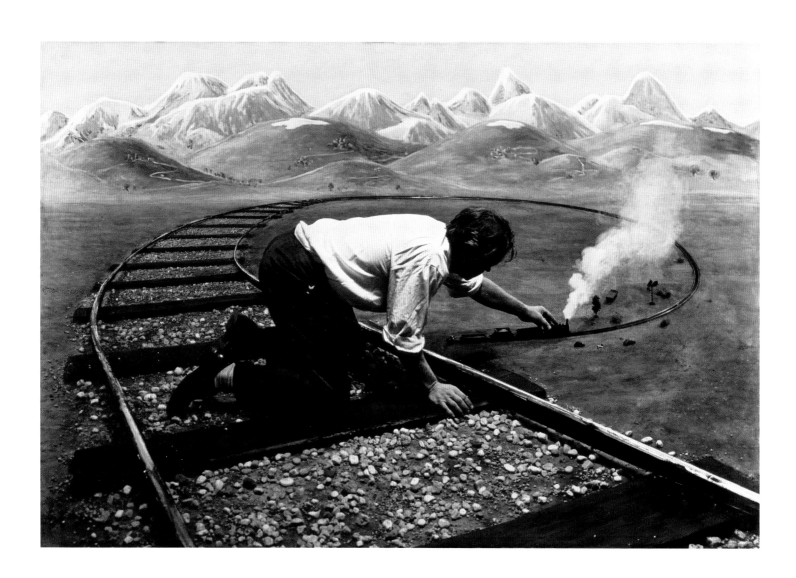

Untitled, 1990
Oil on toned gelatin silver print,
53 x 75⅝ in. (136 x 194 cm)
Edition of 3

Untitled, 1989
Oil on toned gelatin silver print,
50 ⅜ x 53 in. (129 x 136 cm)
Edition of 2

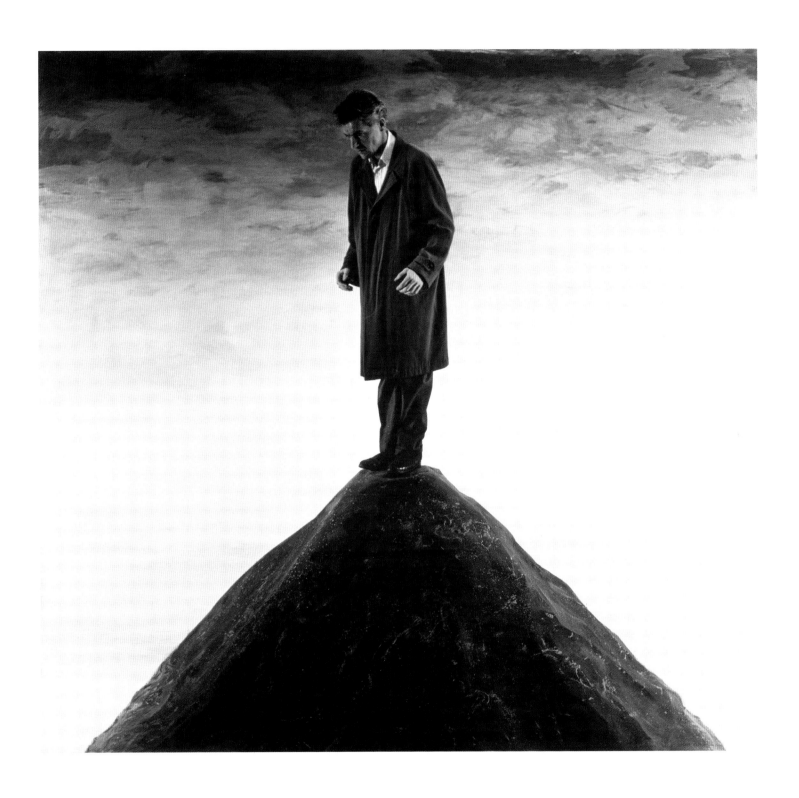

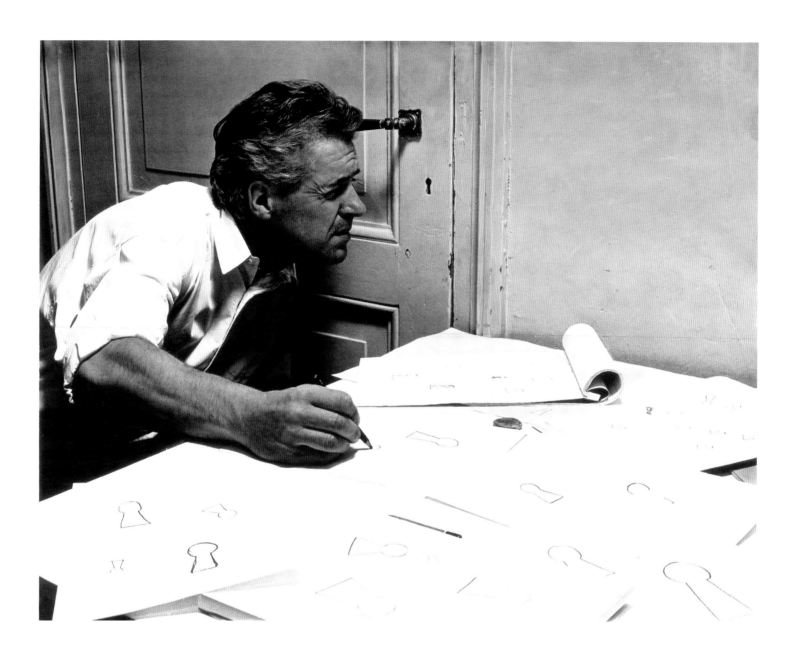

Untitled, 1990

Oil on toned gelatin silver print,

41 ³/₈ x 52 ³/₈ in. (106 x 134 cm)

Edition of 2

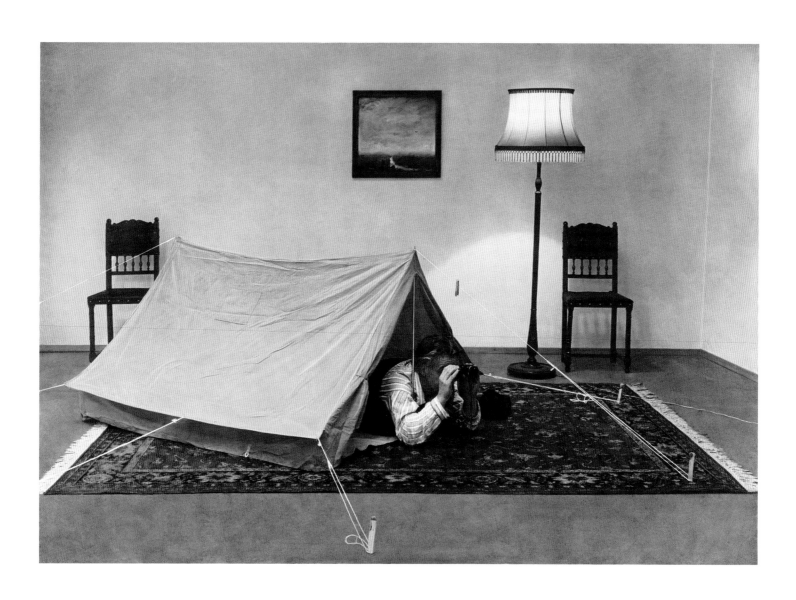

Untitled, 1990
Oil on toned gelatin silver print,
53 x 72¼ in. (136 x 185 cm)
Edition of 3

Untitled, 1991
Oil on toned gelatin silver print,
53 x 65⅞ in. (136 x 169 cm)
Edition of 3, plus 1 AP

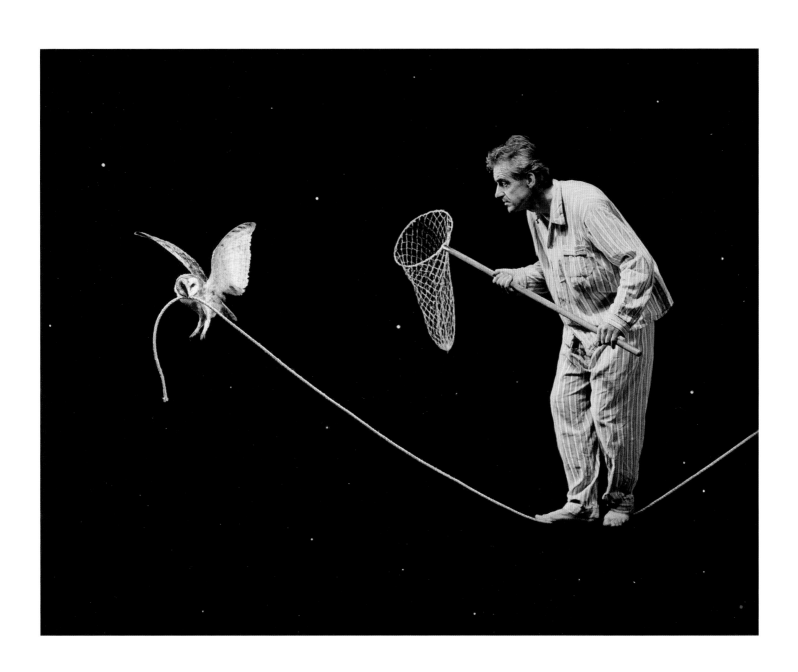

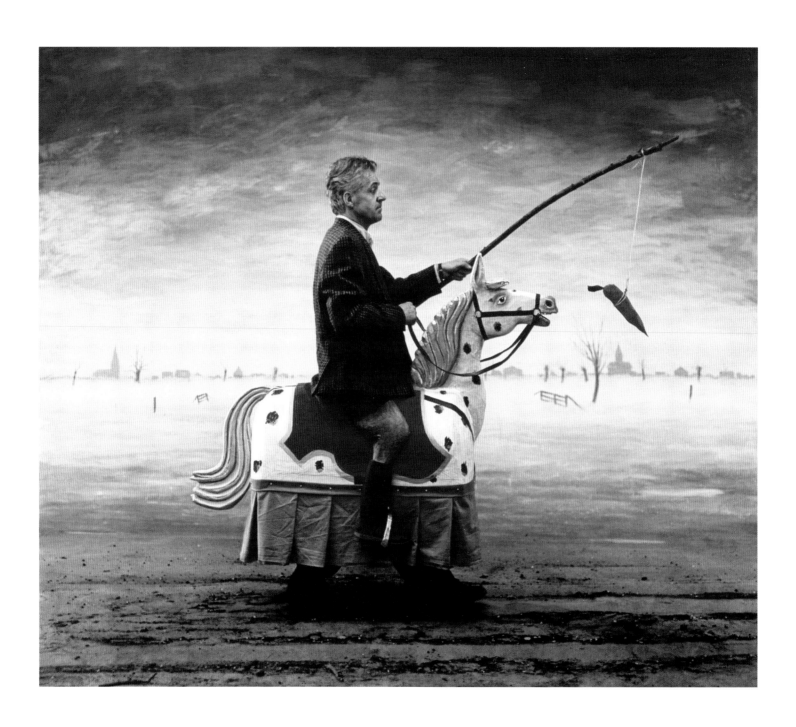

Untitled, 1992
Oil on toned gelatin silver print,
51 1/2 x 59 3/8 in. (132 x 152 cm)
Edition of 3

Horse, 2001
Pencil and colored pencil on paper,
8 1/4 x 11 5/8 in. (21 x 29.7 cm)

Untitled, 1993
Oil on toned gelatin silver print,
64 x 51½ in. (164 x 132 cm)
Edition of 3

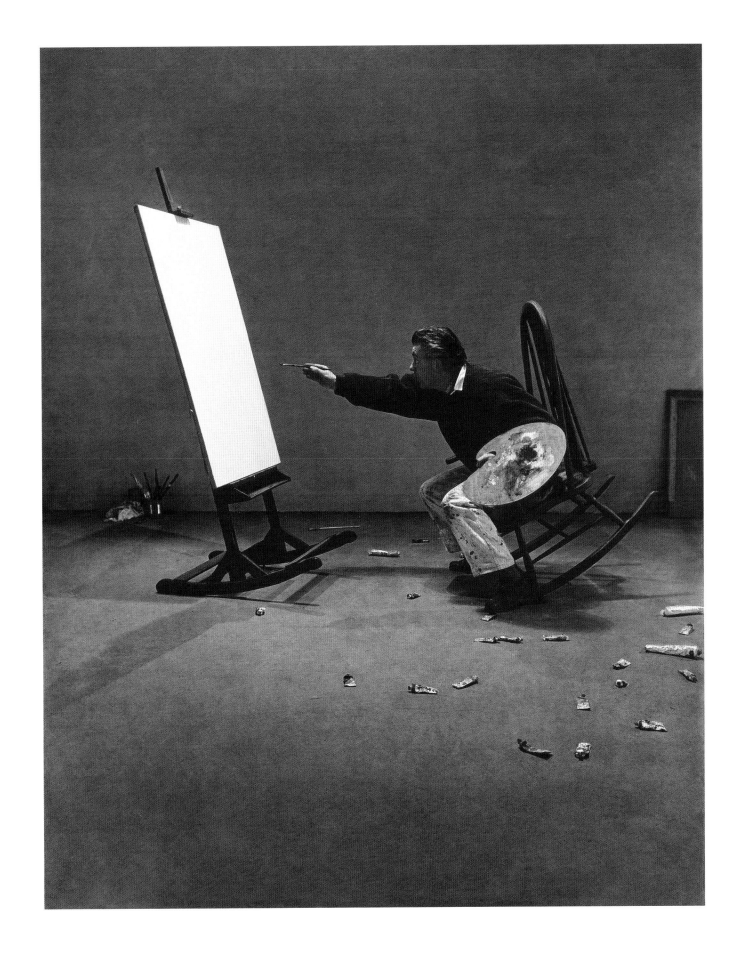

Untitled, 1994
Oil on toned gelatin silver print,
69⅜ x 52⅜ in. (178 x 134 cm)
Edition of 3

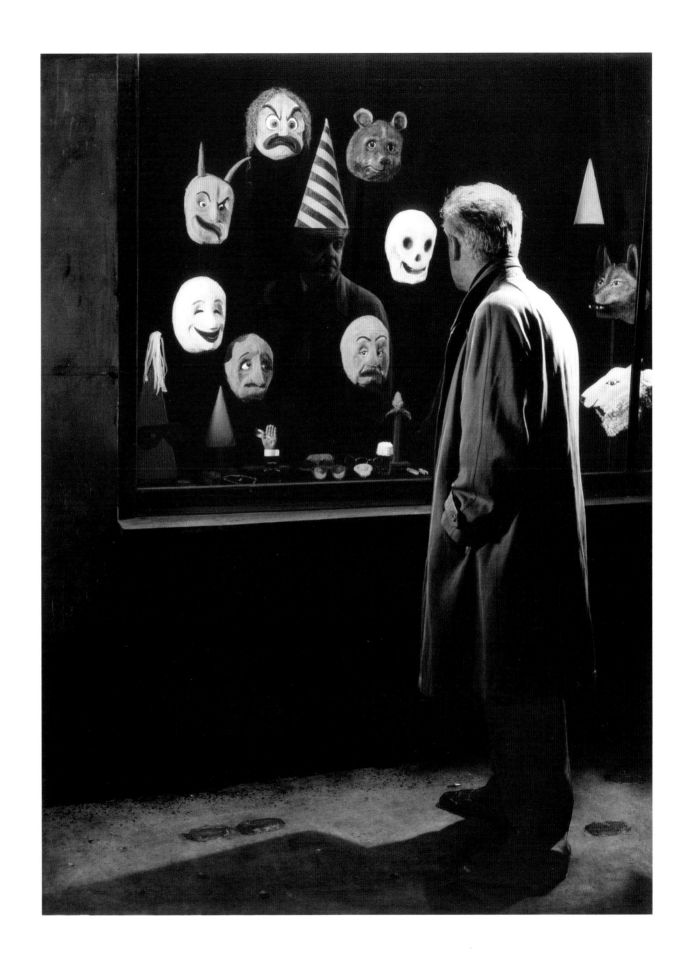

Untitled, 1995

Oil on toned gelatin silver print,

60¾ x 49⅞ in. (156 x 128 cm)

Edition of 3

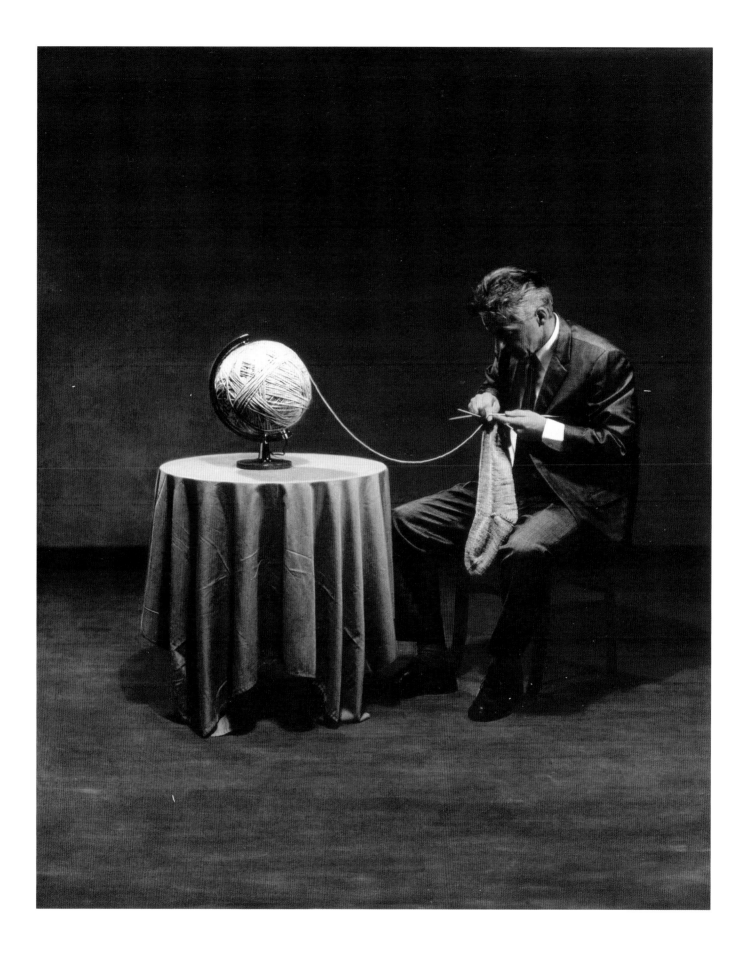

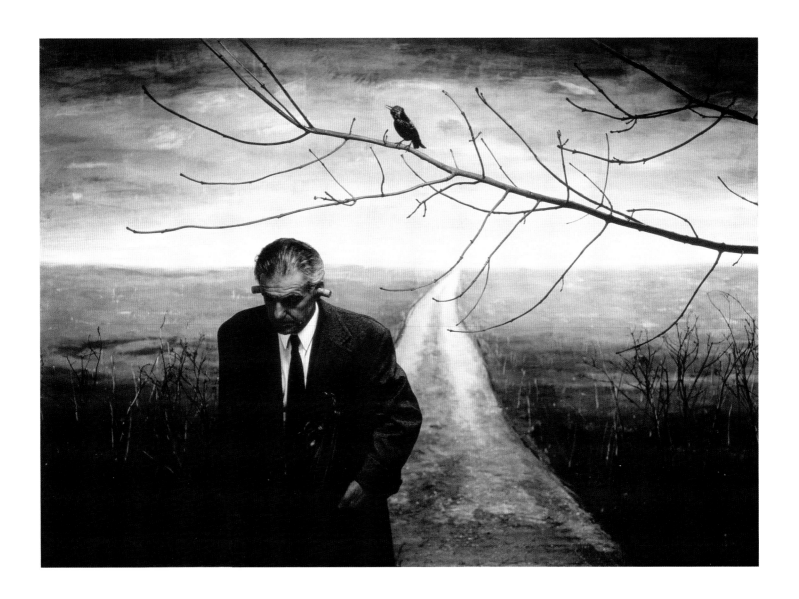

Untitled, 1996
Oil on toned gelatin silver print,
38⅝ x 52⅝ in. (99 x 135 cm)
Edition of 3

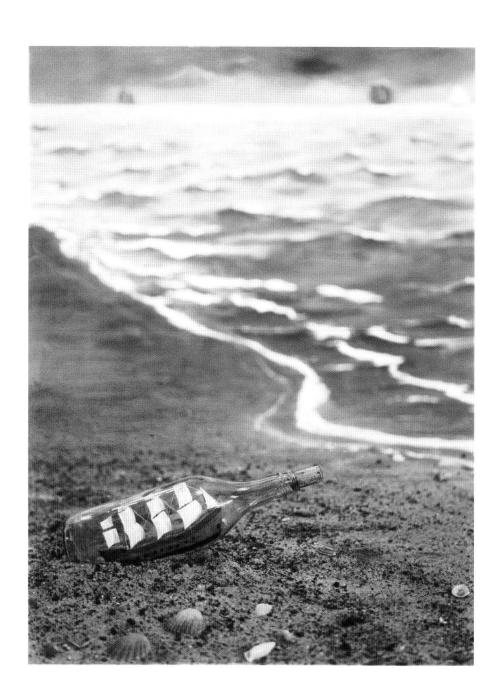

Untitled, 1997
Oil on toned gelatin silver print,
15¾ x 11⅞ in. (40.5 x 30.5 cm)
Edition of 4, plus 1 AP

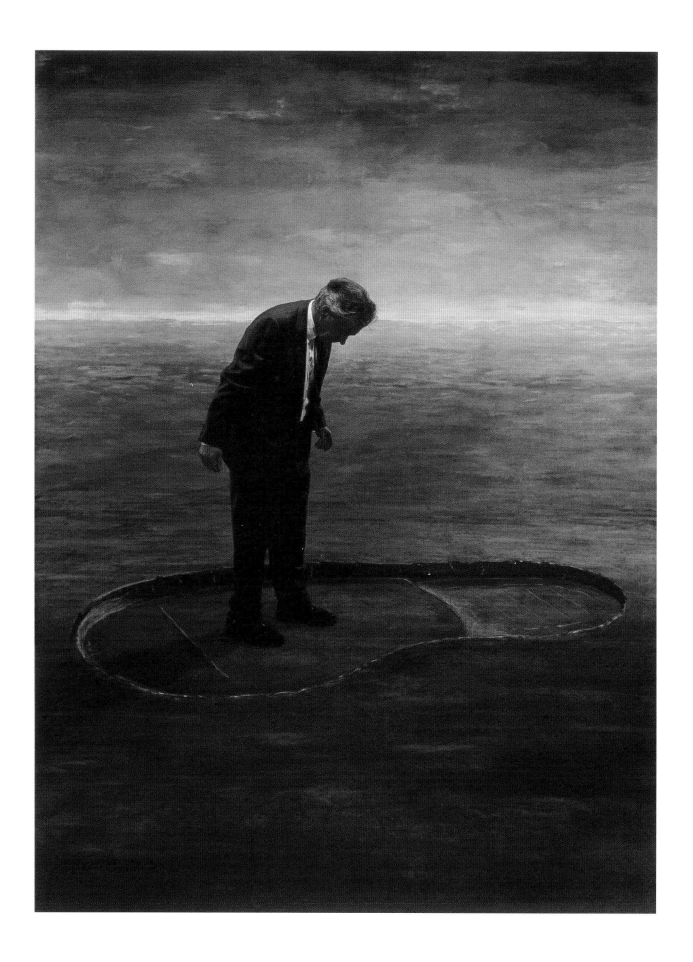

Untitled, 1997
Oil on toned gelatin silver print,
64³/₈ x 48³/₄ in. (165 x 125 cm)
Edition of 3

Untitled, 1997
Oil on toned gelatin silver print,
39¾ x 52⅜ in. (102 x 134 cm)
Edition of 3

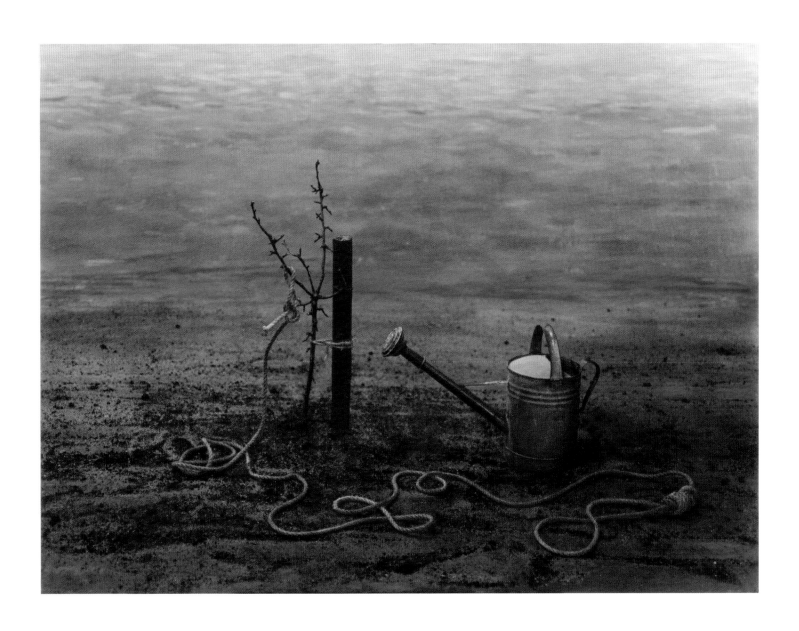

Untitled, 1999
Oil on toned gelatin silver print,
62 x 46¾ in. (159 x 120 cm)
Edition of 3

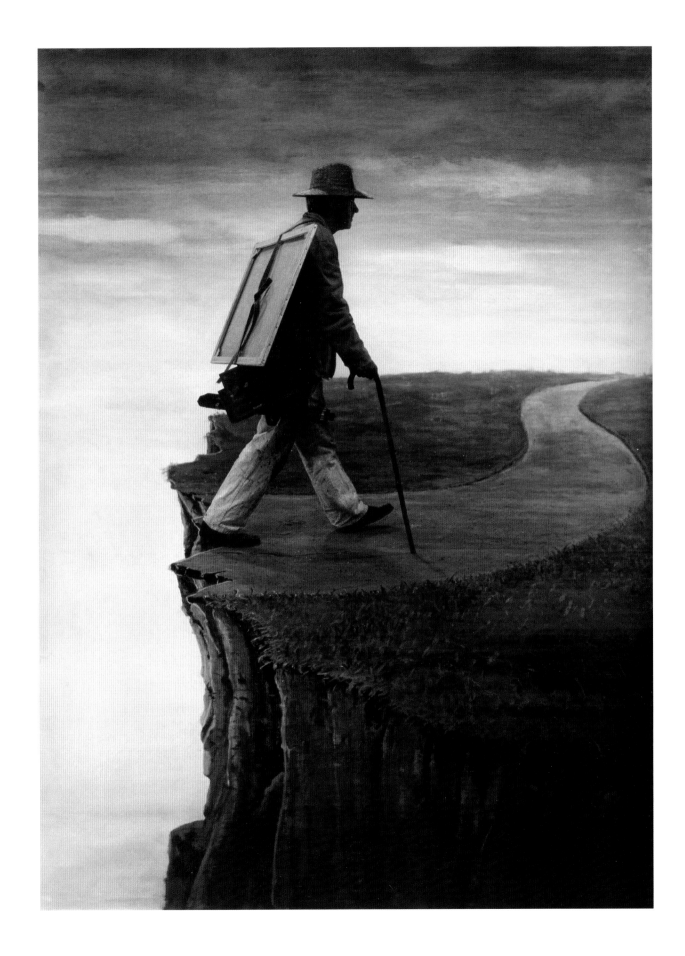

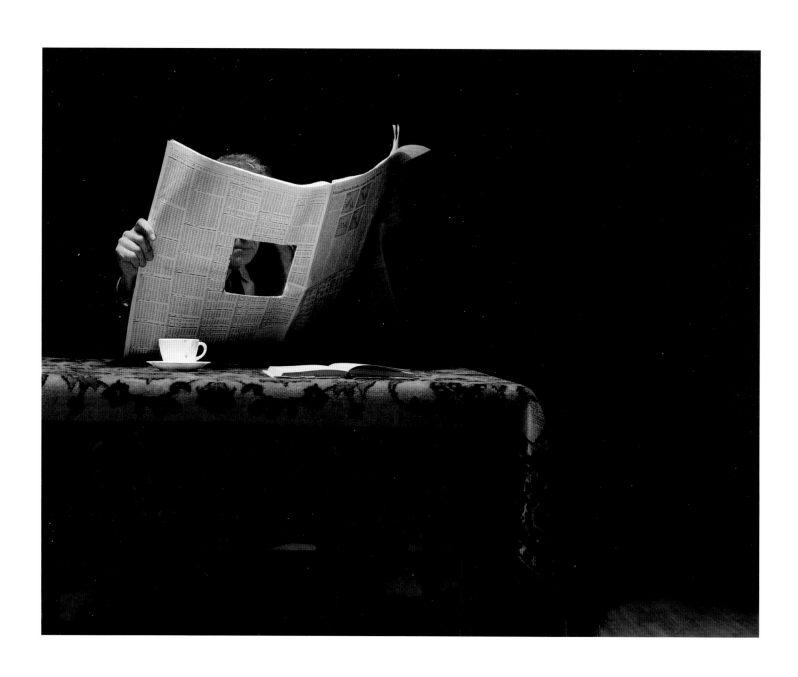

Untitled, 1999
Oil on toned gelatin silver print,
42¼ x 51½ in. (108 x 132 cm)
Edition of 3

Untitled, 1999–2000
Oil on toned gelatin silver print,
46½ x 54⅜ in. (118 x 138 cm)
Edition of 3, plus 1 AP

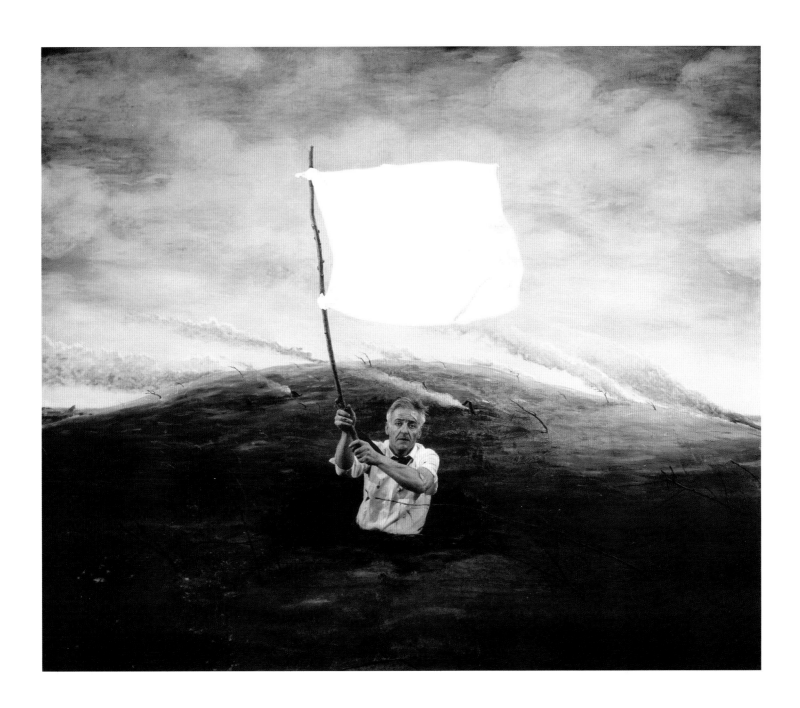

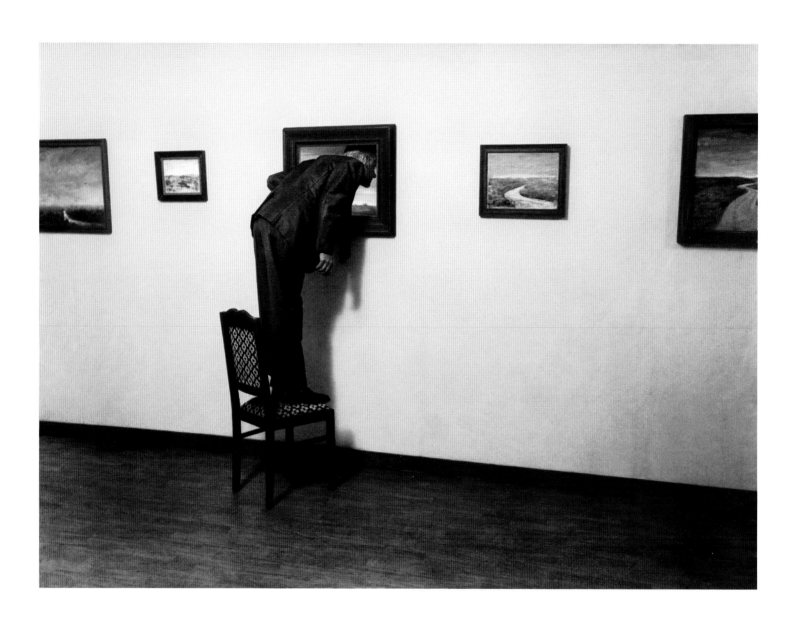

Untitled, 2000
Oil on toned gelatin silver print,
50⅜ x 67¼ in. (129 x 172 cm)
Edition of 3, plus 2 AP

Untitled, 2000
Oil on toned gelatin silver print,
64 x 50½ in. (164 x 129.5 cm)
Edition of 3

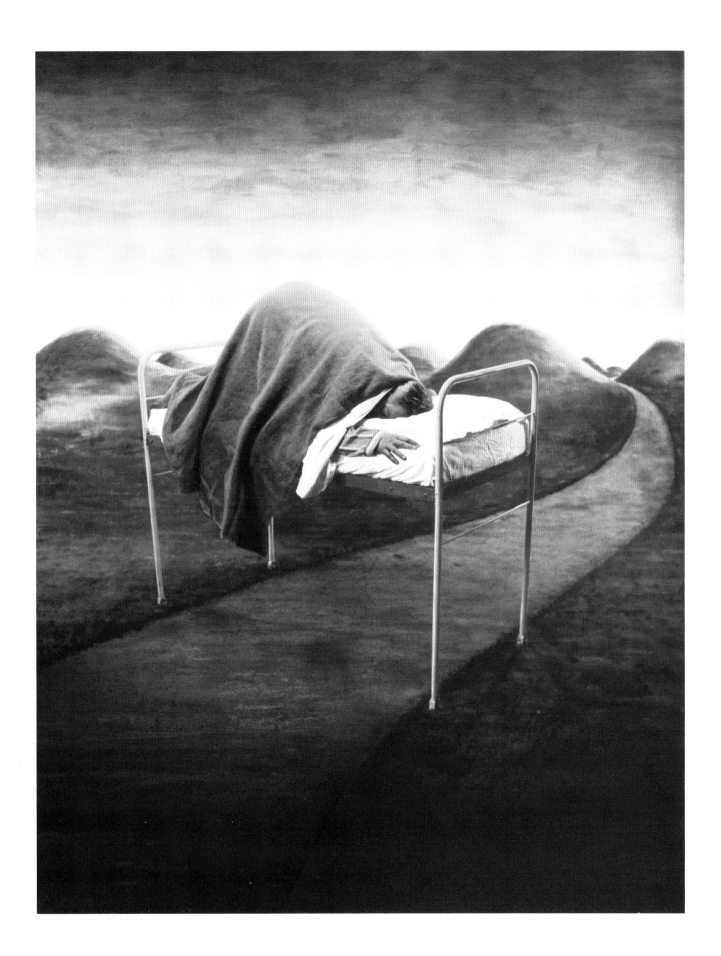

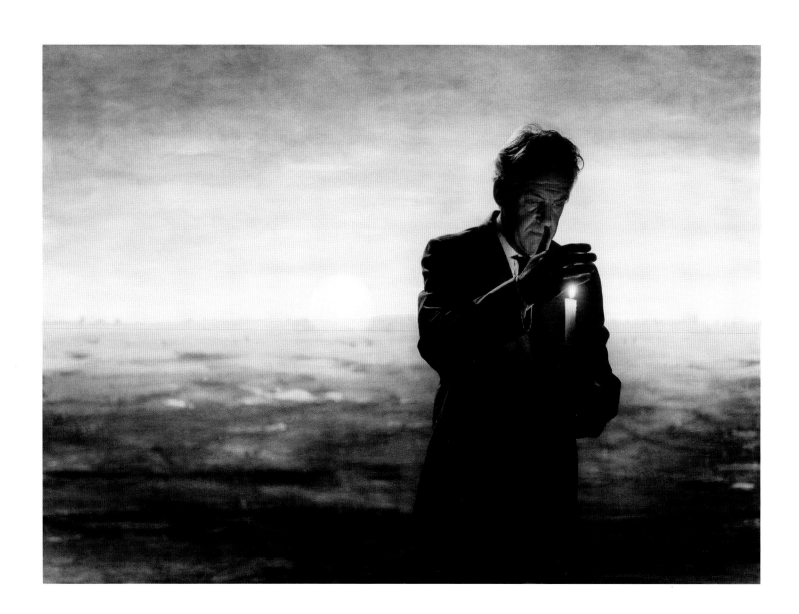

Untitled, 2000

Oil on toned gelatin silver print,

44⅞ x 60¼ in. (115 x 154 cm)

Edition of 3

Untitled, 2000
Oil on toned gelatin silver print,
59 x 52 in. (150 x 132 cm)
Edition of 3

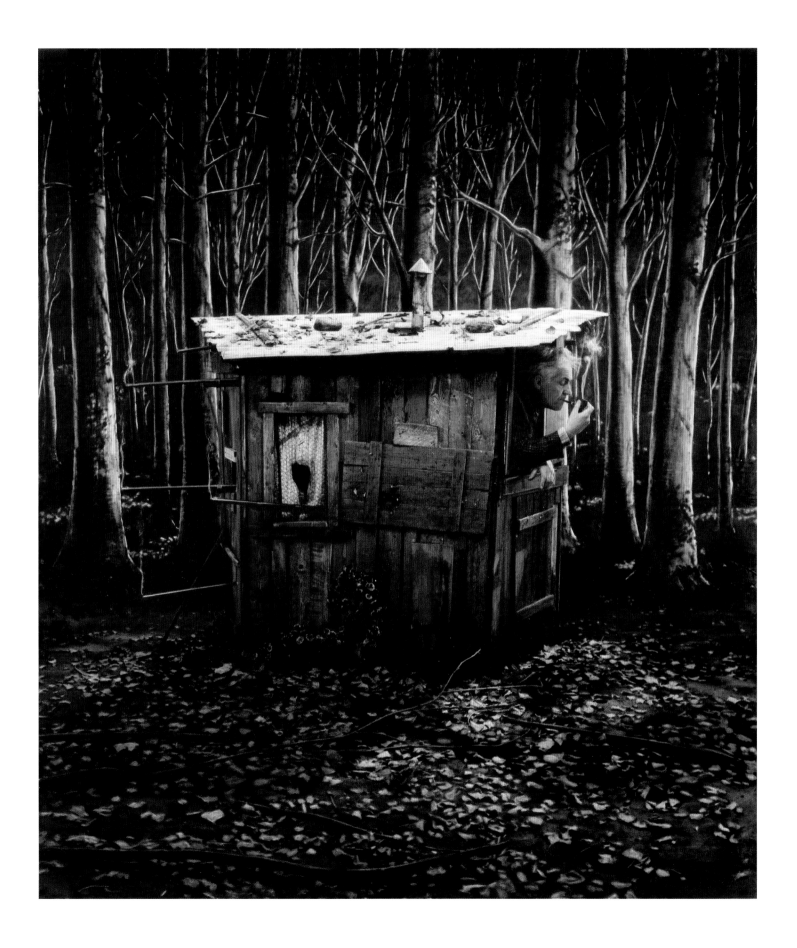

Untitled, 2001
Oil on toned gelatin silver print,
40⅝ x 56⅜ in. (104 x 144.5 cm)
Edition of 3

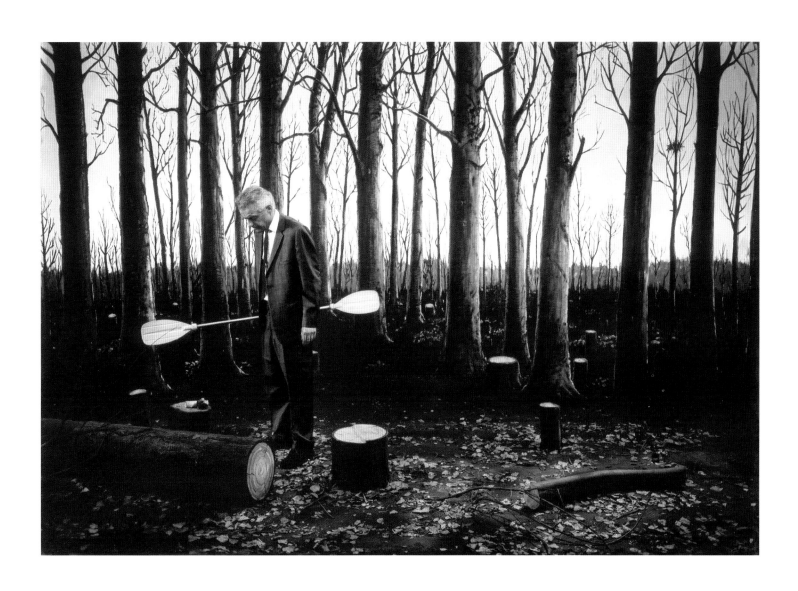

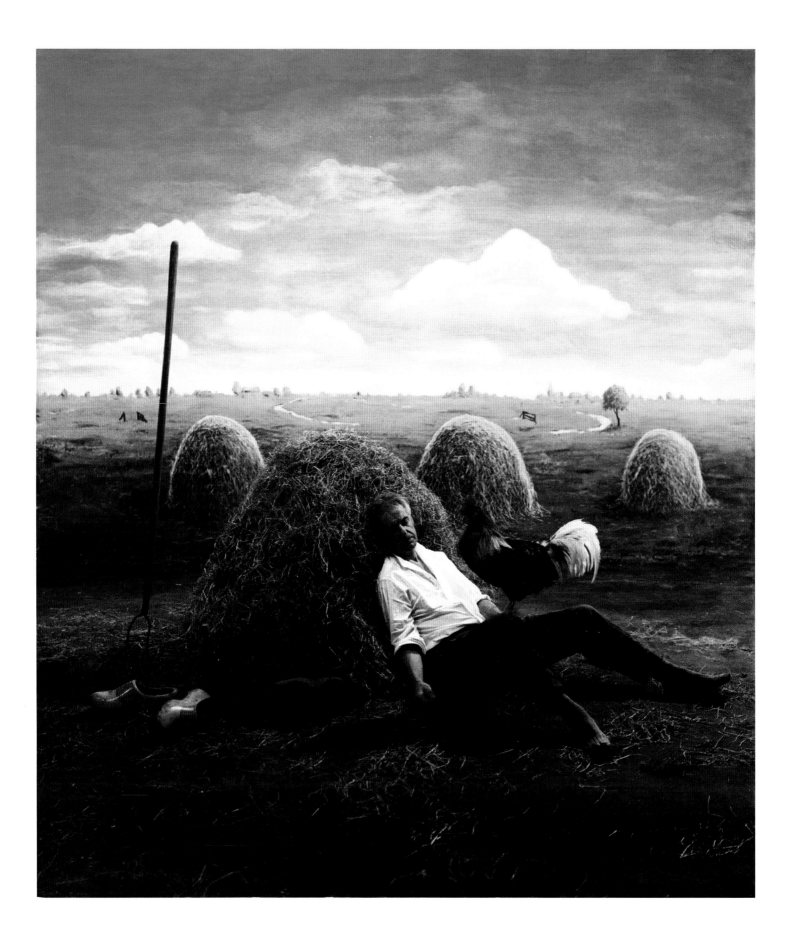

Untitled, 2001
Oil on toned gelatin silver print,
57 ⅝ x 50 ⅞ in. (148 x 130.5 cm)
Edition of 3

Untitled, 2002
Oil on toned gelatin silver print,
51 5/8 x 47 5/8 in. (132.5 x 122 cm)
Edition of 3

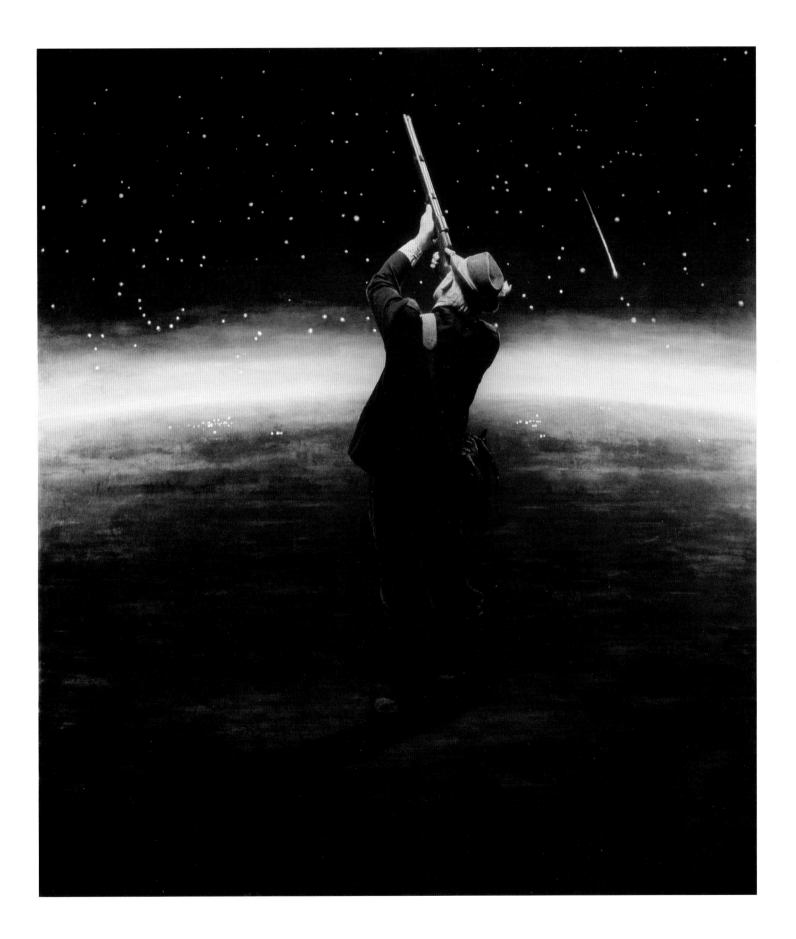

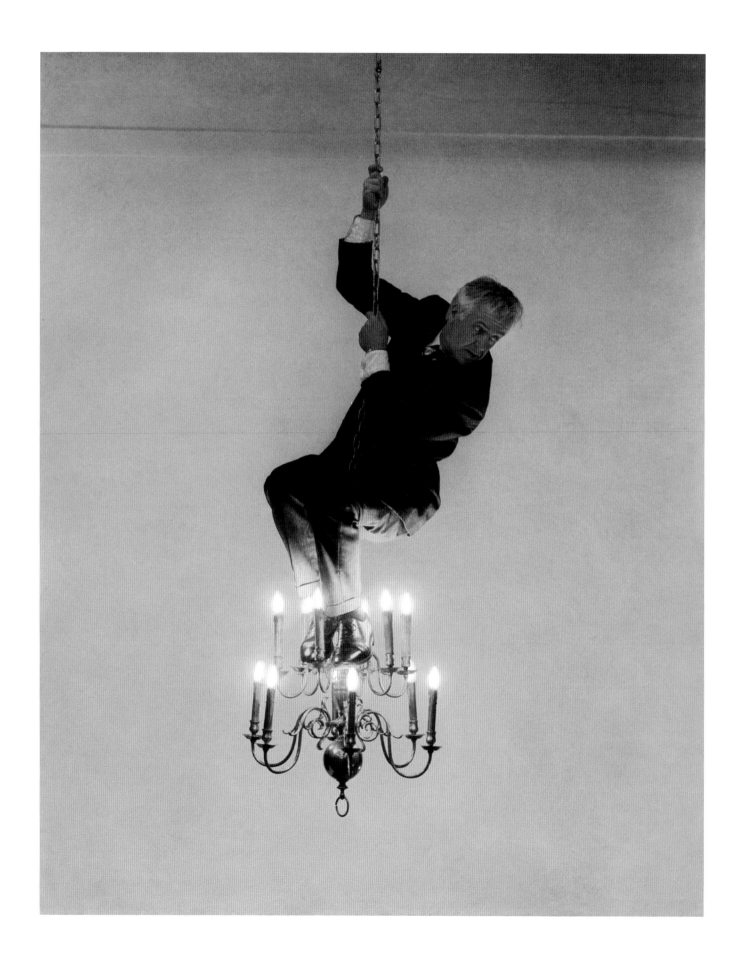

OPPOSITE
Untitled, 2003
Oil on toned gelatin silver print,
57⅞ x 46⅝ in. (148.5 x 119.5 cm)
Edition of 3

BELOW
Lamp, 2001
Ink on paper,
8¼ x 11⅝ in. (21 x 29.7 cm)

Untitled, 2003

Oil on toned gelatin silver print,

44³⁄₈ x 60¼ in. (113.5 x 154 cm)

Edition of 3

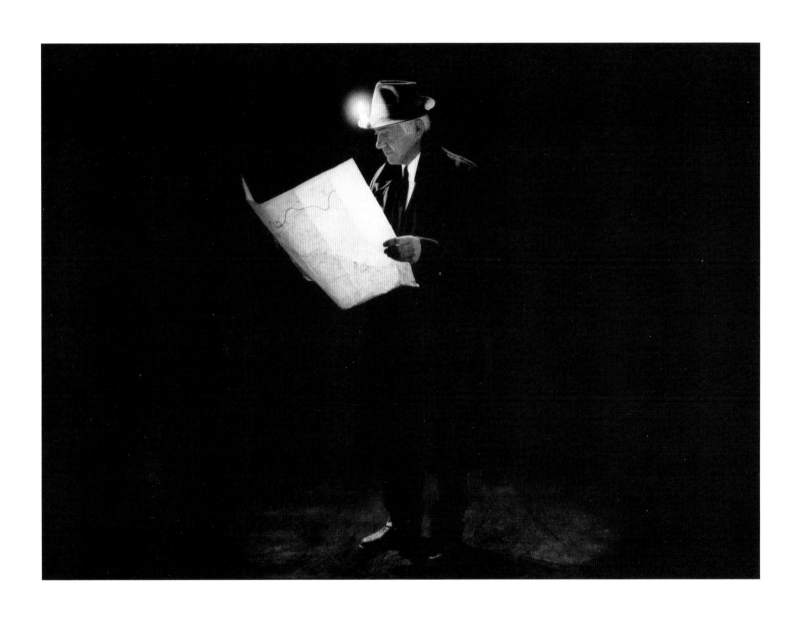

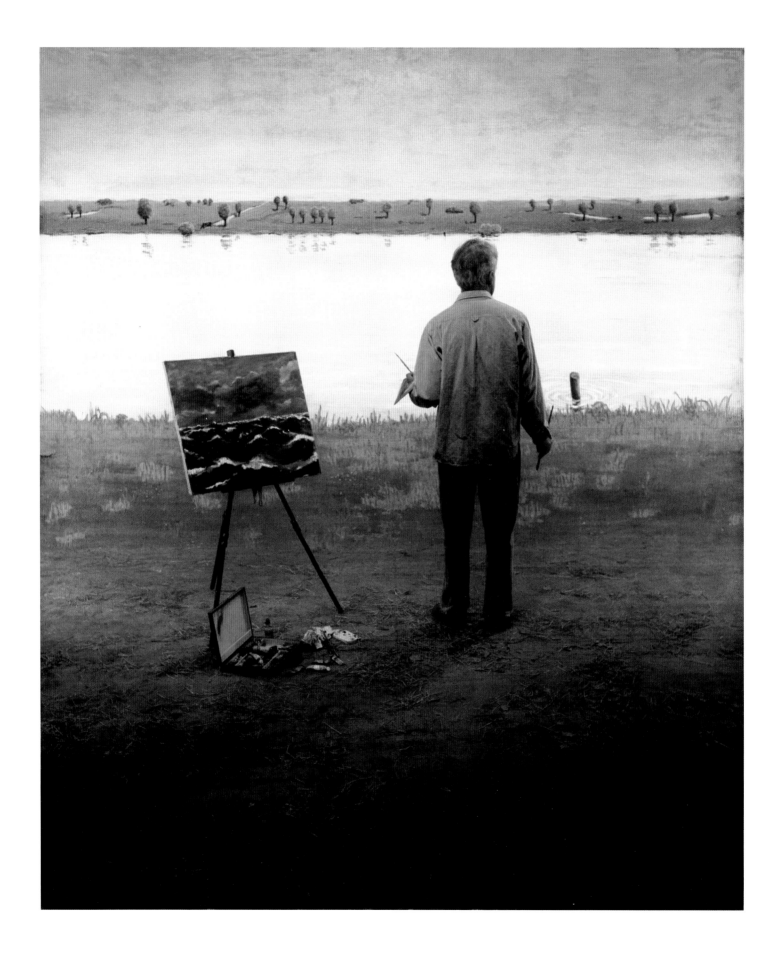

Untitled, 2003
Oil on toned gelatin silver print,
50⅝ x 47¾ in. (130 x 122.5 cm)
Edition of 3

Untitled, 2003
Oil on toned gelatin silver print,
51½ x 49⅞ in. (132 x 128 cm)
Edition of 3

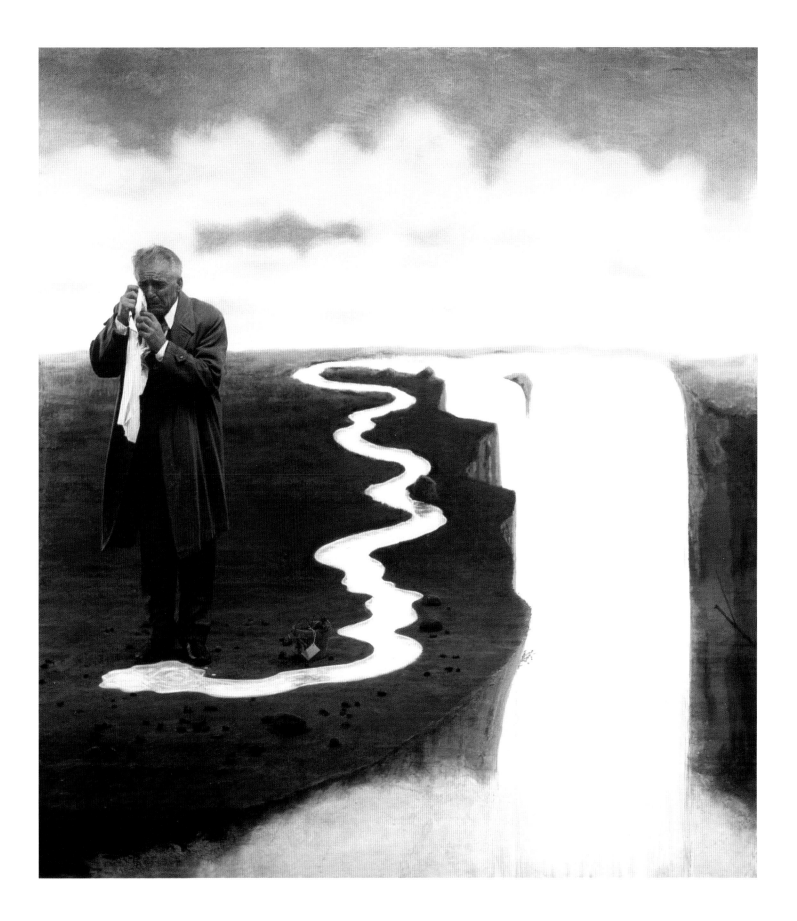

RIGHT

Untitled (Desert), 2004
(drawing from digital video loop)
Pencil on tracing paper,
digitally colored,
8 3/8 x 11 5/8 in. (21 x 29.7 cm)

OPPOSITE

Untitled, 2003
Oil on toned gelatin silver print,
56 x 47 3/4 in. (143.5 x 122.5 cm)
Edition of 3

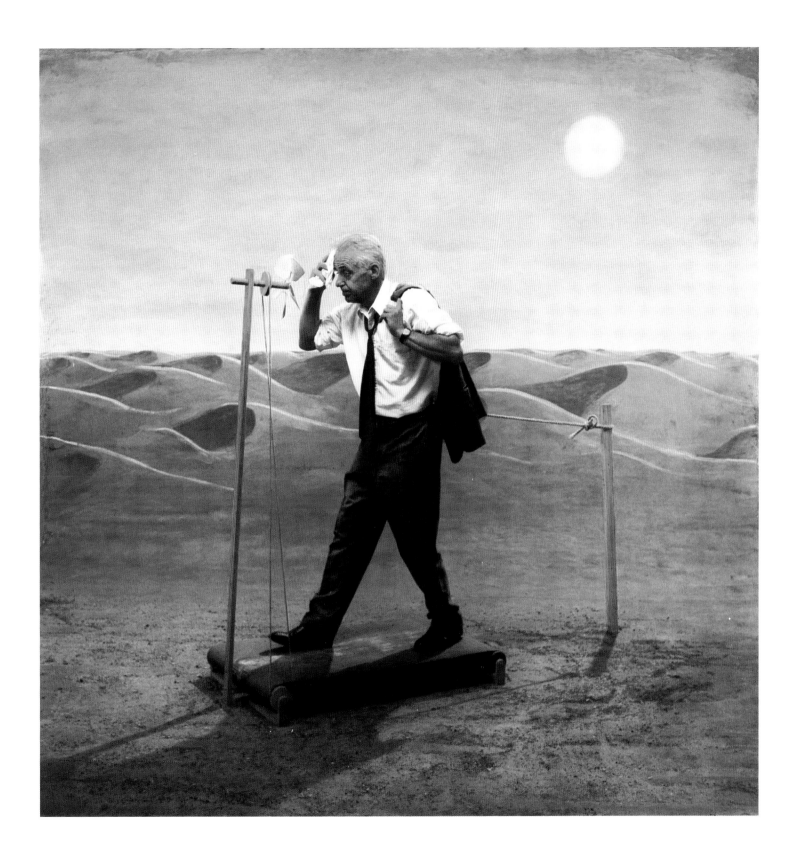

Untitled, 2004
Oil on toned gelatin silver print,
55 7/8 x 47 1/4 in. (142 x 120 cm)
Edition of 3

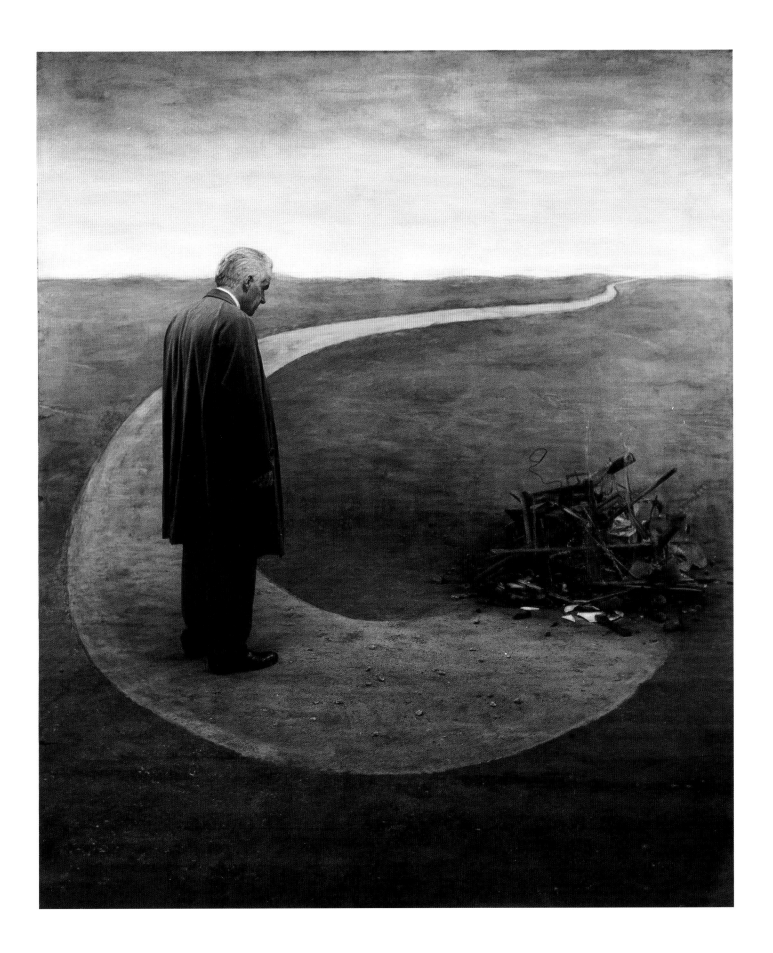

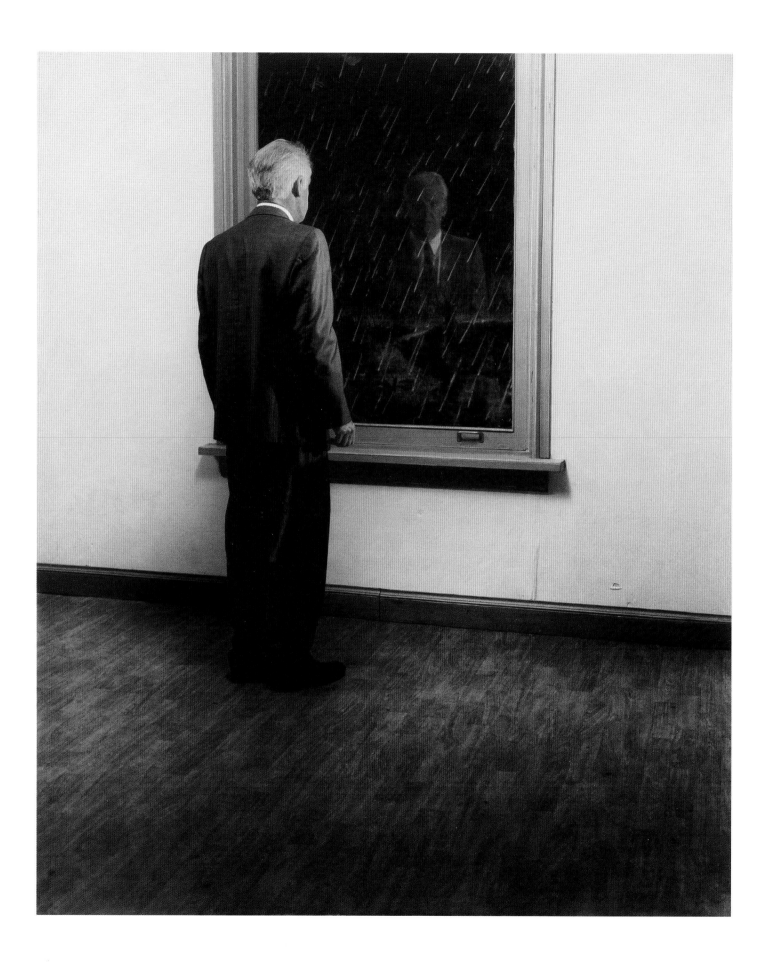

Untitled, 2004
Oil on toned gelatin silver print,
58 ¼ x 49 ¼ in. (149 x 126 cm)
Edition of 3

Untitled, 2004
Oil on toned gelatin silver print,
49¼ x 62 in. (126 x 159 cm)
Edition of 3

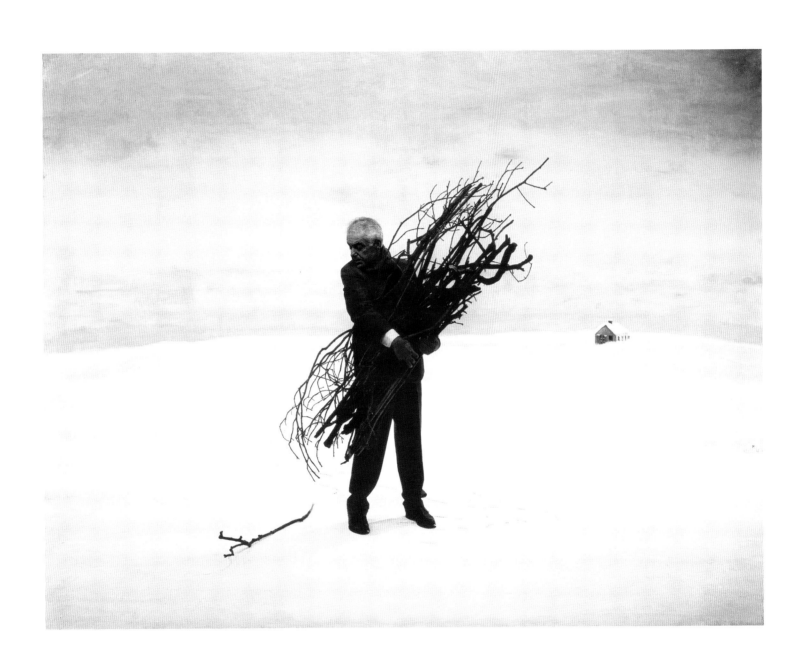

Untitled, 2005
Oil on toned gelatin silver print,
49½ x 65½ in. (127 x 168 cm)
Edition of 3

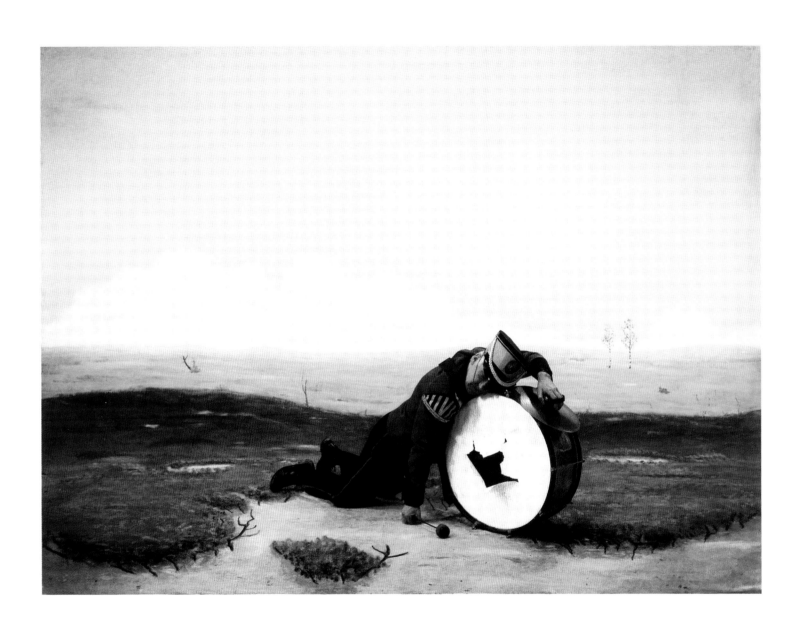

CHRONOLOGY

1947 Teun Hocks is born in Leiden, the Netherlands.
1961 Begins making photographs.
1966–70 Attends Academie Sint Joost, Breda, the Netherlands.
1966–90 Lives in Breda.
1973 Begins painting on photographs.
1977–84 Makes Super 8 films.
1979–85 Does performances.
1980 on Teaches drawing, Design Academy, Eindhoven, the Netherlands.
1986 Joins Torch Gallery, Amsterdam.
1991 on Lives in Breukelen, the Netherlands.
1991– Teaches photography and drawing, Rietveld Academie,
2000 Amsterdam.
1991 Joins P.P.O.W Gallery, New York.
 Awarded Capi-Lux Alblas Prize.
1997 Joins Galerie Patricia Dorfmann, Paris.

SELECTED SOLO EXHIBITIONS

1979 Galerie Lóa, Amsterdam.
1986 Torch Gallery, Amsterdam.
 Gallery Fotomania, Leiden, the Netherlands.
1988 Beursschouwburg, Brussels.
 Institut Néerlandais, Paris.
1989 Galerie 121, Antwerp, Belgium.
 Dany Keller Galerie, Munich.
 Artlantis, Stuttgart, Germany.
1990 Torch Gallery, Amsterdam.
1991 Galerie 121, Antwerp.
 P.P.O.W Gallery, New York.
 Bellamy 19, Stedelijk Museum Vlissingen,
 Vlissingen/Flushing, the Netherlands.
1992 Cold City Gallery, Toronto.
 Perspektief, Rotterdam.
 Galeria Nova, Rome.
 Torch Gallery, Amsterdam.
 Galerie 15, Paris.
1993 P.P.O.W Gallery, New York.
 Galerie 15, Paris (FIAC).
 Galerie 121, Antwerp.
1994 Galerie Bob Coppens, Brussels.
 Boulder Art Center, Boulder, Colorado.
 Torch Gallery, Amsterdam.
1995 California State University Art Museum, Long Beach.
 La Lune & Parachute, Epinal, France.
 Neue Galerie, Bad Marienberg, Germany.
1996 Galerie Anita Beckers, Darmstadt, Germany.
 De Zonnehof, Amersfoort, the Netherlands.
1997 D. B. Kunstlok 2, Göppingen, Germany.
 Torch Gallery, Amsterdam.
 Galerie Bob Coppens, Brussels.
 Galerie Patricia Dorfmann, Paris.
 P.P.O.W Gallery, New York.
 Antiquariaat L. van Paddenburgh, Leiden, the Netherlands.
1999 Torch Gallery, Amsterdam.
 P.P.O.W Gallery, New York.
 Galerie Patricia Dorfmann, Paris.
 Het late uur, De Beyerd, Breda, the Netherlands.

Groninger Museum, Groningen, the Netherlands.
 Het late uur, Provinciaal Museum voor Moderne Kunst,
 Oostende, Belgium.
2000 *Teun Hocks: Commedia dell'Arte Dutch Style,* Chinese
 European Art Center, Xiamen City, China.
 The Late Hour, Lightbox Project, Metropolitan Transportation
 Authority: Arts for Transit, Grand Central Station,
 New York.
2001 Gasunie, Groningen, the Netherlands.
 P.P.O.W Gallery, New York.
 A.M.C. Kunststichtring Academisch Medisch Centrum,
 Amsterdam.
 Galerie Patricia Dorfmann, Paris (Paris Photo).
2002 Galerie Patricia Dorfmann, Paris.
 Cotthem Gallery, Barcelona.
2003 Fahey/Klein Gallery, Los Angeles.
 Torch Gallery, Amsterdam.
 Teun Hocks: Made in Holland, Cotthem Gallery, Brussels.
2004 P.P.O.W Gallery, New York.

SELECTED PERFORMANCES

1980 Performance in *Aanvallen van uitersten* (Attack of
 Extremes), Theater Lantaren Venster, Rotterdam.
 "Hé, kijk pompoenen" (Hey, Look, Pumpkins!), Hotel
 Brittannië, Vlissingen/Flushing, the Netherlands.
1983 *Eeuwig zingen de zagen* (Saws Singing Forever),
 Perfotijd, Theater Lantaren Venster, Rotterdam.
1984 *Het Donkere-Kamerorkest* (The Dark Chamber Orchestra),
 Centrum Beeldende Kunst, Rotterdam.
 Eeuwig zingen de zagen uit het Donkere-Kamerorkest
 (Saws Singing Forever, from the Dark Chamber
 Orchestra), Melkweg, Amsterdam.
1985 *Eeuwig zingen de zagen uit het Donkere-Kamerorkest*
 (Saws Singing Forever, from the Dark Chamber
 Orchestra), in "Talking Back to the Media,"
 Shaffy Theater/Kable TV, Amsterdam.

SUPER 8 FILMS

1977 *Op een ochtend* (One Morning). 3 minutes.
 Atlas. 3 minutes.
1979 *Fragmenten en korte schetsen* (Fragments and Short
 Sketches)—seven short films, including *Rainbow
 Cleaning Service.*
 Nieuwe avonturen (New Adventures)—fifteen short films,
 including *Scenario, Concerto-Introverto, Etude,* and
 Surfer on the Beach.
1984 *En hoe het verder ging (Narcissen voor een spiegel)*
 (And How Things Went On [Daffodils in Front of a
 Mirror])—twelve short films, including *Pluto, Saturnus,
 Vrienden en kennissen* (Friends and Acquaintances),
 Just Another Pair of Shoes, and *Protest.*

VIDEOS

2000 *Tentoonstelling* (Exhibition). About 5 minutes, black and
 white, digital video looped on DVD.
 Eeuwig zingende zagen (Eternal Singing Saws).
 About 7 minutes, color, digital video looped on DVD.
2001 *Zonder titel* (Te paard)/*Untitled* (On Horseback).

2002 About 10 minutes, color, digital video looped on DVD.
Zonder titel (Lamp)/*Untitled* (Lamp).
About 5 minutes, color, digital video looped on DVD.

2004 *Regen* (Rain). About 5 minutes, color, digital video looped on DVD.
Theater. About 1 minute, animation on digital video looped on DVD.
Zonder titel (Woestijn)/*Untitled* (Desert). Animation on digital video looped on DVD.

2005 *Drum*. About 10 minutes, color, digital video looped on DVD.

SELECTED BOOKS, CATALOGS, AND PERIODICALS

1985 Ter Hofstede, Poul, ed. *Fotografia Buffa: Staged Photography in the Netherlands.* Groningen, the Netherlands: Groninger Museum.

1989 Honnef, Klaus. *Kunst der Gegenwart.* Cologne: Taschen Verlag.
Invention d'un art: Cent cinquantième anniversaire de la photographie. Paris: Centre Georges Pompidou.
Köhler, Michael. *Das konstruierte Bild.* Schaffhausen, Zurich: Edition Stemmle.

1991 Decter, Joshua. "P.P.O.W, New York: Exhibit." *Arts Magazine* 66 (October): 96–97.
von Graevenitz, Antje. *Teun Hocks.* Amsterdam: Art Books Unlimited.

1992 French, Christopher, and Terrie Sultan. "Report from the Netherlands: A New Internationalism." *Art in America* 80 (July): 43–51.
Trickett, Ian. "Teun Hocks." *Vis à vis International,* no. 11 (Spring): 60–63.
Turner, Jonathan. *Double Dutch: Il realismo nell'arte contemporanea olandese.* Rome: Edigraf Editoriale Grafica.

1993 "Portfolio Teun Hocks." *Aperture* 130 (Winter): 32–37.
Hagen, Charles. "Teun Hocks." *New York Times,* June 18.

1996 Traylor, Janet. "Focus on Corporate Photography." *PDN Photo District News* 16, no. 10 (October): 48–50. *Untitled* (man with umbrella, standing in a flowerpot), 1990, reproduced on cover; *Untitled* (man with rocket on his back), 1987, p. 48; *Untitled* (man with hats and coats), 1995, *Untitled* (ringmaster with burning frame), 1993, and *Mathematical Notations*, 1987, all on p. 49; *Untitled* (sailor building an SOS note in a bottle), 1995, p. 50.

1997 "Teun Hocks." *Blind Spot,* no. 10 (Fall): 7–14.
Haveman, Mariëtte, and Carlo McCormick. *Teun Hocks.* Amsterdam: Torch Books, in collaboration with P.P.O.W Gallery, New York; Galerie Bob Coppens, Brussels; Galerie Patricia Dorfmann, Paris; Galerie Anita Beckers, Darmstadt, Germany.
Koplos, Janet. "Teun Hocks at P.P.O.W." *Art in America* 86 (March): 109.
Sand, Michael L. "Magical Folly." *World Art,* no. 18: 48–53.

1999 Byrd, Cathy. "Land, Lots of Land: Eclectic Landscapes, a Show in Two Places." *Creative Loafing* 27 (February): n.p.
Kuspit, Donald. *Teun Hocks: Het late uur/The Late Hour.* Breda, the Netherlands: Uitgeverij De Geus.

2001 Hefting, Paul. *Teun Hocks.* Venlo, the Netherlands: Gasunie/Van Spijk Art Projects.
Johnson, Ken. "Teun Hocks." *New York Times,* July 13.

Kuspit, Donald. "Teun Hocks, P.P.O.W." *Artforum* 40 (October): 160.
"Teun Hocks." *Blind Spot,* no. 18 (Summer): 54–59.
Steenbergen, Renée. *Alles onder controle.* Nijmegen, the Netherlands: Museum Het Valkhof.

2002 Van Der Geer, Cees. "His Own Protagonist: The Work of Teun Hocks." In *The Low Countries: Arts and Society in Flanders and the Netherlands.* 10th yearbook, pp. 172–77. Flanders, Belgium: Flemish Netherland Foundation.

2003 "Teun Hocks." Interview by Qin Jian. In *A Series on Contemporary European Artists.* Xiamen, China: Chinese European Art Center of Xiamen University Art College.

2004 Pérez, Luis Francisco. "Teun Hocks o la melancolia del virtuoso/Teun Hocks or the Melancholy of a Master." *Exit* 13 (February–April): 44–71.

SELECTED PROJECTS, ILLUSTRATIONS, AND COMMISSIONS

1992 Cover for the Chills CD, *Soft Bomb.* Slash/Reprise.

1993 Teun Hocks and Dromen van Stof. "Dreams of Fabric." *Avenue Magazine,* no. 8 (September): 64–71.
Four telephone cards for PTT Telecom, December.

1995 Annual Report, Progressive Corporation, Mayfield Village, Ohio.
Poster for Orkater's music theater, *Who Killed Mary Rogers?*

1997 Kinderpostzegels (serie: Sprookjes)/Postage stamps (series: Fairy Tales).
"The World as It Was and the Events That Changed It." *Life Millennium Issue* 20 (special double issue, Fall): 59, 73, 106–7. *Landscape*, 1989, p. 59; *Untitled* (man with a bomb, looking at his watch), 1993, p. 73; *Untitled* (man under an apple tree, with a weight tied to his feet), 1997–98, p. 106.
Teun Hocks-Kunstlok/Art-locomotive. Full-size locomotive covered with images for the Deutsche Bahn. Issued by Mårklin as a model in HO and in Z scale and by Trix model trains in Minitrix.

1998 Poster for Orkater's music theater, *The Formidable Yankee.*
"The Doctor Is Not In." *Harper's Magazine,* March. Untitled (man writing with intravenous ink supply), 1996, reproduced on cover.

1999 Chabon, Michael. "The Hofzinser Club." *New Yorker,* July 19, pp. 78–84. *Untitled* (man behind a curtain), 1993, p. 78.

2003 "Get Rich or Get Out." *Harper's Magazine*, June. *Untitled* (man stealing the moon), 1988, reproduced on cover.
Mendelsohn, Daniel. "The Melodramatic Moment." *New York Times Magazine,* March 23, pp. 40–43. *Untitled* (man crying a river), 2003, p. 41; *Untitled* (man by a small river, wringing out a handkerchief), 2003, p. 43.

2004 Kureishi, Hanif. "Long Ago Yesterday." *New Yorker,* March 8, pp. 74–78. *Untitled* (man hanging on chandelier), 2003, p. 74.

2004–5 Design for three stained-glass windows for the St. Joriskapel of the Grote Kerk, Dordrecht, the Netherlands.

2005 "96 Amazing and Endearing Facts That Will Forever Change the Way You Look at Man." *Oprah Magazine,* June. *Untitled* (man with carrot dangling in front of his horse costume), 1992, pp. 206–7; *Untitled* (man with lampshade on his head), 1979/89, p. 208; *Untitled* (man in front of a shop window with masks), 1994, p. 217.

FRONT COVER: Detail of *Untitled*, 2003 (page 9)

BACK COVER: Detail of *Untitled*, 2003 (page 85)

FRONT CASE: Detail of drawing for *Untitled*, 2003 (page 7)

BACK CASE: Detail of *Untitled (Desert)*, 2004 (page 84)

PAGE 1: *Painter and Camera*, 1985. Pencil on paper,
11⅝ x 8¼ in. (29.7 x 21 cm)

FRONTISPIECE: Detail of *Untitled*, 2000 (page 62)

EDITOR: Nancy Grubb
DESIGNER: Patricia Fabricant
PRODUCTION: Bryonie Wise
REPRODUCTION PHOTOGRAPHY: Marius Klabbers

The staff for this book at Aperture Foundation includes:
Ellen S. Harris, *Executive Director;* Michael Culoso, *Director of Finance and Administration;* Lesley A. Martin, *Executive Editor, Books;* Carmel Lyons, *Assistant Editor;* Andrea Smith, *Director of Communications;* Kristian Orozco, *Director of Sales and Foreign Rights;* Diana Edkins, *Director of Special Projects;* Albane Sappey, *Work Scholar*

Teun Hocks was made possible with generous support from The Netherland-America Foundation and from the Mondriaan Foundation, Amsterdam.

First edition
Printed and bound in Italy
10 9 8 7 6 5 4 3 2 1

Library of Congress Control Number: 2005929616
ISBN 1-931788-78-2

Aperture Foundation books are available in North America through:
D.A.P./Distributed Art Publishers
155 Sixth Avenue, 2nd Floor
New York, N.Y. 10013
Phone: (212) 627-1999
Fax: (212) 627-9484

Aperture Foundation books are distributed outside North America by:
Thames & Hudson
181A High Holborn
London WC1V 7QX
United Kingdom
Phone: + 44 20 7845 5000
Fax: + 44 20 7845 5055
Email: sales@thameshudson.co.uk

aperturefoundation
547 West 27th Street
New York, N.Y. 10001
www.aperture.org

The purpose of Aperture Foundation, a non-profit organization, is to advance photography in all its forms and to foster the exchange of ideas among audiences worldwide.

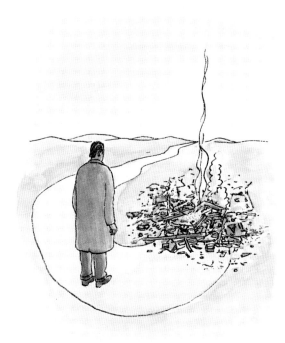

Dead End, 2004
Watercolor on photocopy on paper,
11⅝ x 8¼ in. (29.7 x 21 cm)